APERTURE

EDITED WITH AN INTRODUCTION BY JONATHAN GREEN

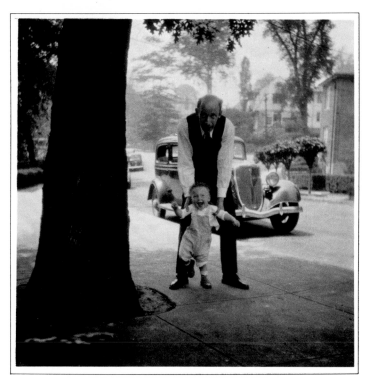

The SNAPSHOT
is published as Aperture, Volume 19, Number 1,
and as a book for general distribution. The
photographs and text in this publication have
been brought together and prepared by Jonathan
Green. The publication is set in Linofilm Memphis
Light with Manhattan headlines. It was printed by
Rapoport Printing Corporation and bound by
Sendor Bindery. The design is by Stephen Korbet.

Aperture, Inc. publishes a quarterly of photography,
portfolios, and books to communicate with serious
photographers and creative people everywhere. A
complete catalogue will be mailed upon request.
Address: Elm Street, Millerton, New York 12546.

Library of Congress catalogue card no. 74-18754
ISBN: Clothbound 0-912334-67-3
 Paper bound 0-912334-68-1
Manufactured in the United States of America

INTRODUCTION

The word *snapshot* is the most ambiguous, controversial word in photography since the word *art*.

It has been bandied about as both praise and condemnation. It has been discussed as both process and product. A snapshot may imply the hurried, passing glimpse or the treasured keepsake; its purpose may be casual observation or deliberate preservation. The snapshot may look forward in time to a chaotic, radically photographic structure, the appropriate equivalent of modern experience; or it may look backward to the frontal formal family portrait of a bygone age.

The continuous existence of millions of unpretentious, evanescent photographic images has formed a cultural and visual presence which has influenced the mainstream of photographic production in the twentieth century. This publication, through a series of articles, interviews and portfolios, examines the vitality and ambiguity of the naïve home snapshot and its bearing upon a variety of approaches used by contemporary photographers. The photographers represented here do not belong to any single school or style. They do not all use the hand camera. They do not all choose the same subject. They are not snapshooters but sophisticated photographers. Yet their intentional pursuit of the plastic controls and visual richness hinted at in the work of the casual amateur, or their explorations of familial subject matter, involves their work with the ongoing tradition of the home snapshot.

Jonathan Green

Snapshot Album, 1923

 The SNAP-SHOT

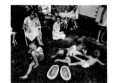

EMMET GOWIN

8

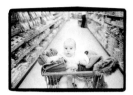

GUS KAYAFAS

50

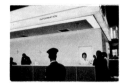

GARRY WINOGRAND

84

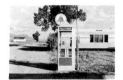

HENRY WESSEL, JR.

16

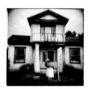

NANCY REXROTH

54

BILL ZULPO-DANE

96

TOD PAPAGEORGE

28

WENDY SNYDER MACNEIL

68

LEE FRIEDLANDER

112

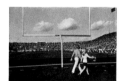

JOEL MEYEROWITZ

36

RICHARD ALBERTINE

80

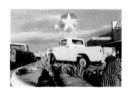

ROBERT FRANK

120

LISETTE MODEL:

I am a passionate lover of the snapshot, because of all photographic images it comes closest to truth. The snapshot is a specific spiritual moment. It cannot be willed or desired to be achieved. It simply happens, to certain people and not to others. Some people may never take a snapshot in their lives, though they take many pictures.

Snapshots can be made with any camera—old cameras, new cameras, box cameras, Instamatics and Nikons. But what really makes them occur is a specific state of mind. A snapshot is not a *performance*. It has no pretence or ambition. It is something that happens to the taker rather than his performing it. Innocence is the quintessence of the snapshot. I wish to distinguish between innocence and ignorance. Innocence is one of the highest forms of being and ignorance is one of the lowest. The

professional photographer, in spite of the instantaneous and spontaneous means at his disposal, can never achieve that degree of innocence. He may try to imitate the snapshot. He may wait on purpose for the loose, unconventional moment. The moment may be unstructured, but the photographer is not. He may make a masterpiece by selecting the moment but he can never make a snapshot.

We should remember that much of the power of snapshots comes from their centering on basic everyday experience; images of children at their birth and later stages of growth, pictures of families, friends, relatives and old people about to die, of the house, ceremonial occasions, meals, trips, landscapes, vacations, beloved animals. And sometimes taking snapshots is purely conventional. One has a child, one takes snapshots. One has par-

ents, one takes snapshots. One has an album because others have albums. The snapshot also confers status. People dress up to have their pictures taken, they give themselves to the snapshot with pride. They photograph their new car, their new possessions, anything that they want to be remembered.

But what the eye sees is different from what the camera records. Whereas the eye sees in three dimensions, images are projected on a surface of two dimensions, which for every image-maker is a great problem. The snapshooter disregards this problem, and the result is that his pictures have an apparent disorder and imperfection, which is exactly their appeal and their style. The picture isn't straight. It isn't done well. It isn't composed. It isn't thought out. And out of this imbalance, and out of this not knowing, and out of this real innocence toward the medium comes an enormous vitality and expression of life. The look of a snapshot is so similar around the world that it amounts to a universal style. What makes it so recognizable as a style is not only its unpretentious visual aspects but the elemental life from which it springs.

We are all so overwhelmed by culture and by imitation culture that it is a relief to see something which is done directly, without any intention of being good or bad, done only because one wants to do it.

If I were to print a book of snapshots, I would do it in its own spirit. On the front page there would be one snapshot, and in the inside pages would be loosely distributed images, without introduction, without philosophy, without explanations, without captions, so that for once people would be free to discover for themselves, without being told what to see.

From 1966 to 1970 my admiration for the homemade picture was highest. What I admired was filtered directly into my photographs. I was becoming alive to certain essential qualities in family photographs. Above all, I admired what the camera made. The whole person was presented to the camera. There was no interference, or so it seemed. And sometimes the frame cut through the world with a surprise. There could be no doubt that the picture belonged more to the world of things and facts than to the photographer.

By my marriage to Edith Morris I entered a family freshly different from my own. I admired their simplicity and generosity and I thought of the pictures I made then as agreements. I wanted to pay attention to the body and personality that had agreed out of love, it seemed to me, to reveal itself. My paying attention was a natural duty which could honor that love.

"When all is said and done," writes Werner Heisenberg, "reality is stronger than all our wishes." I wanted to celebrate both clarity and fact. For me, the problem is always to find the shape of the gesture, the feeling of space, a light, which holds again a sense of touching reality.

EMMET GOWIN

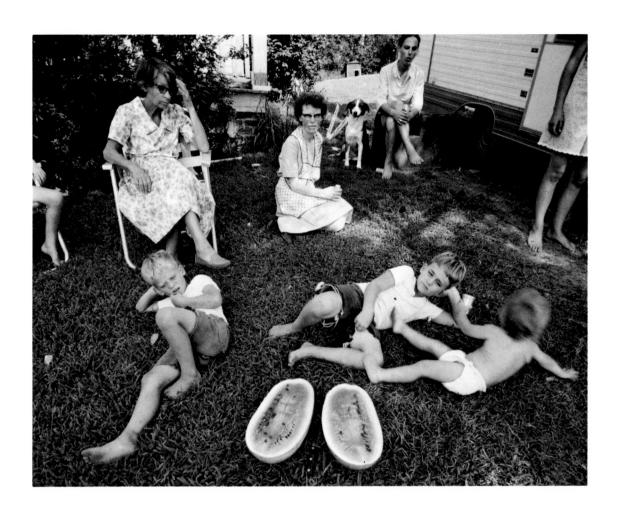

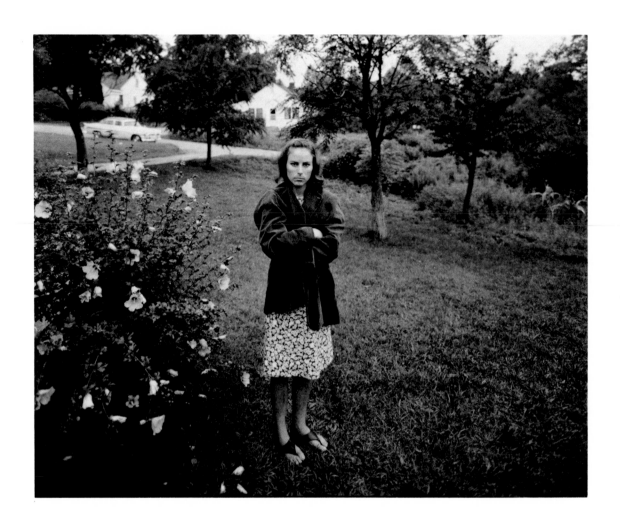

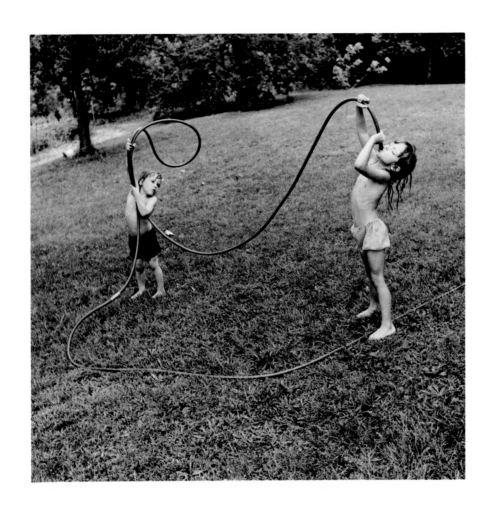

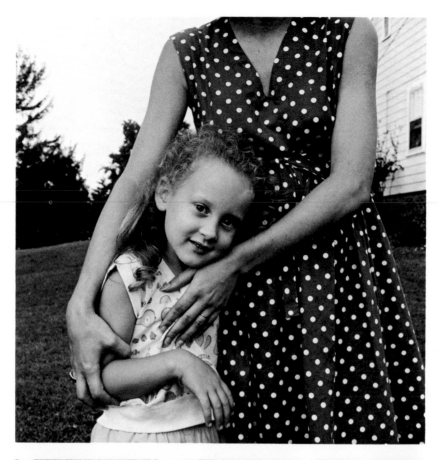

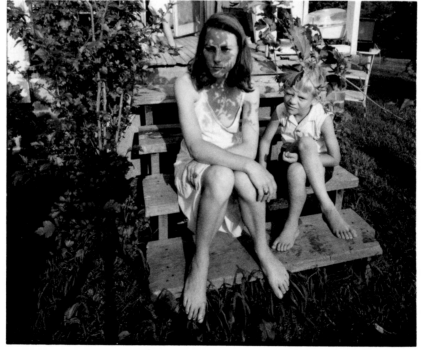

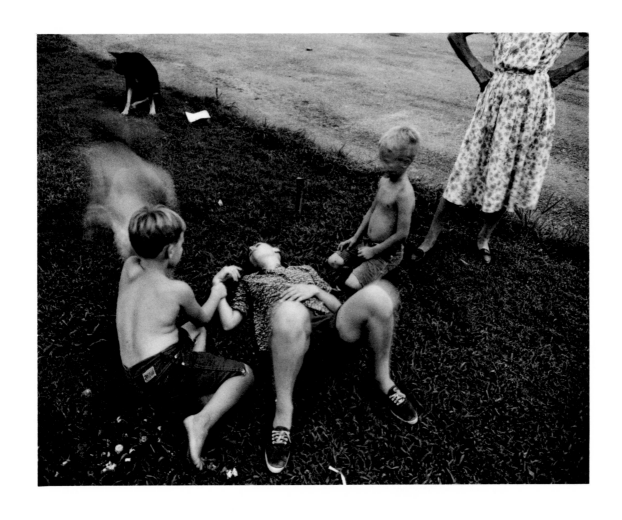

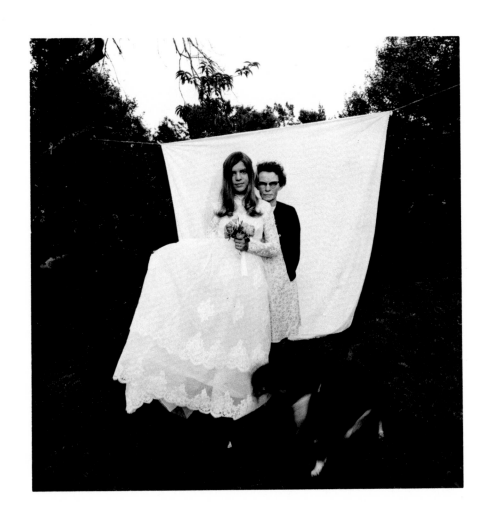

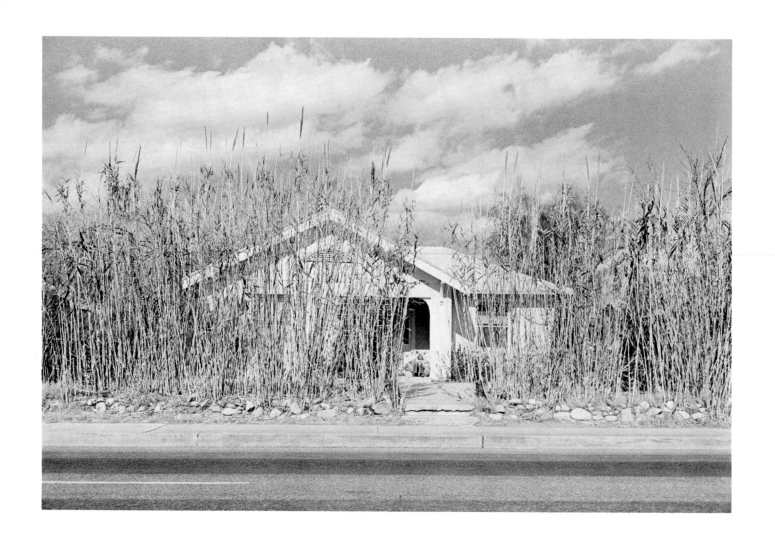

HENRY WESSEL, JR.

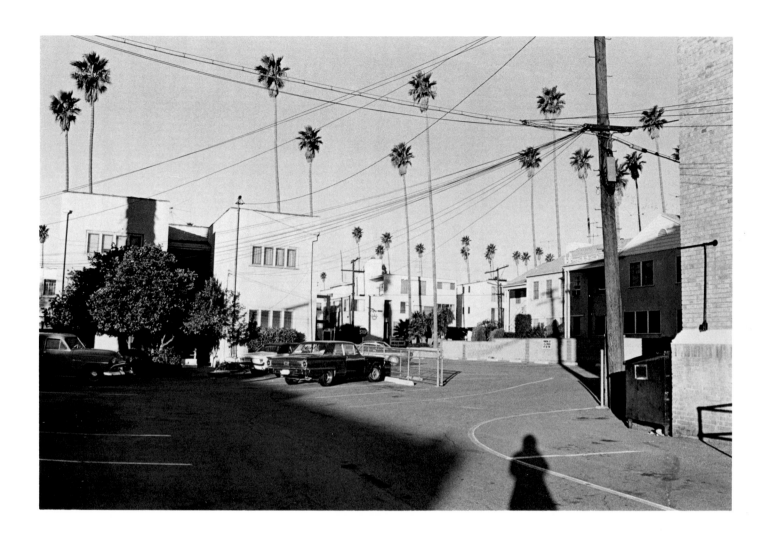

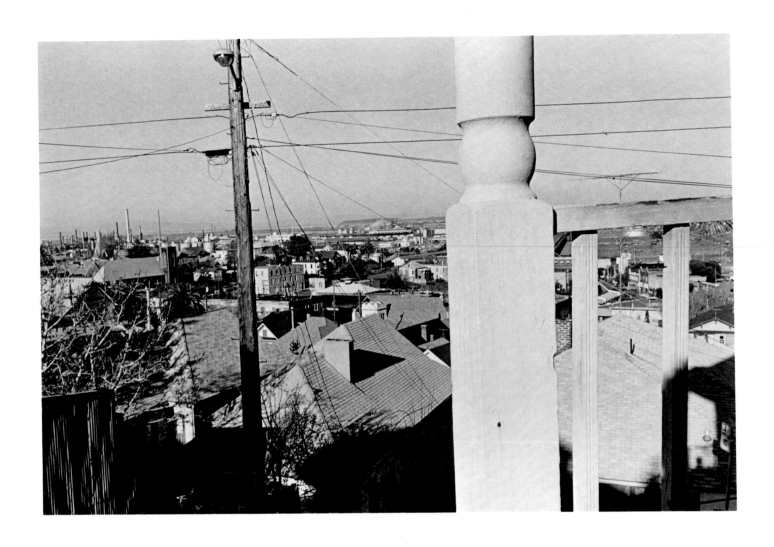

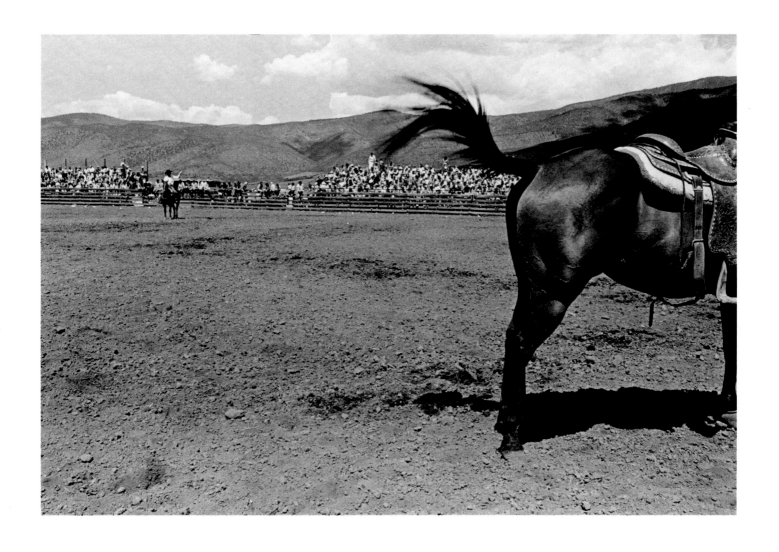

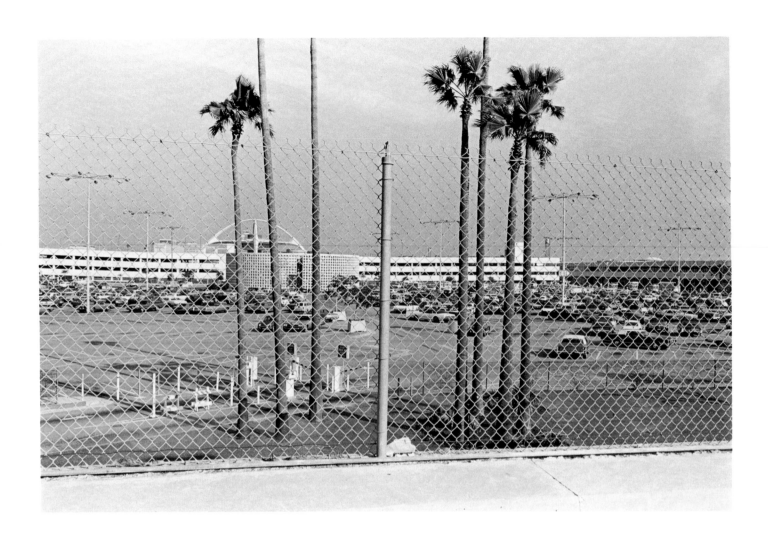

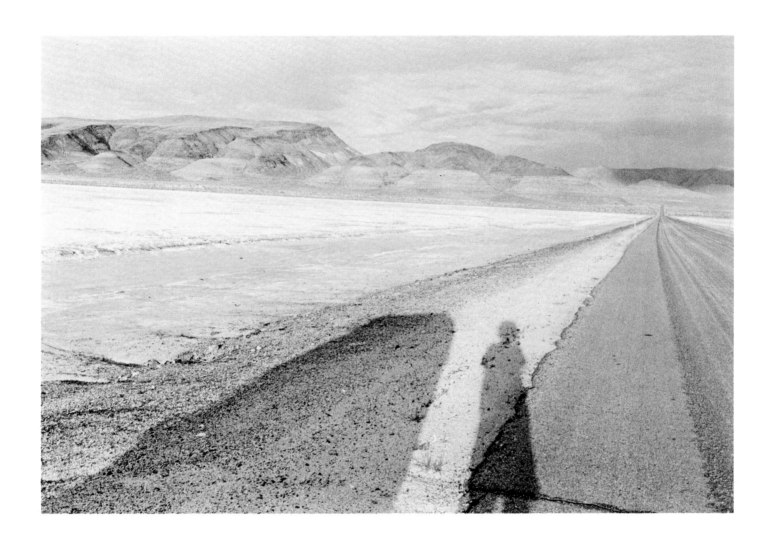

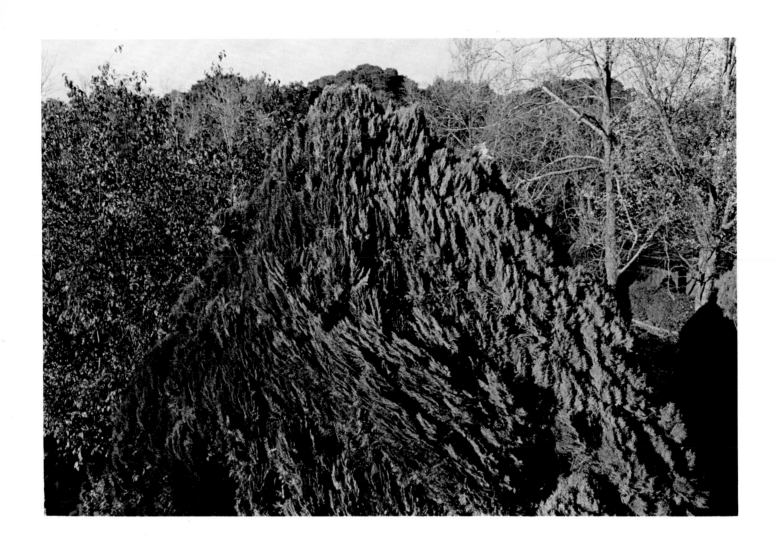

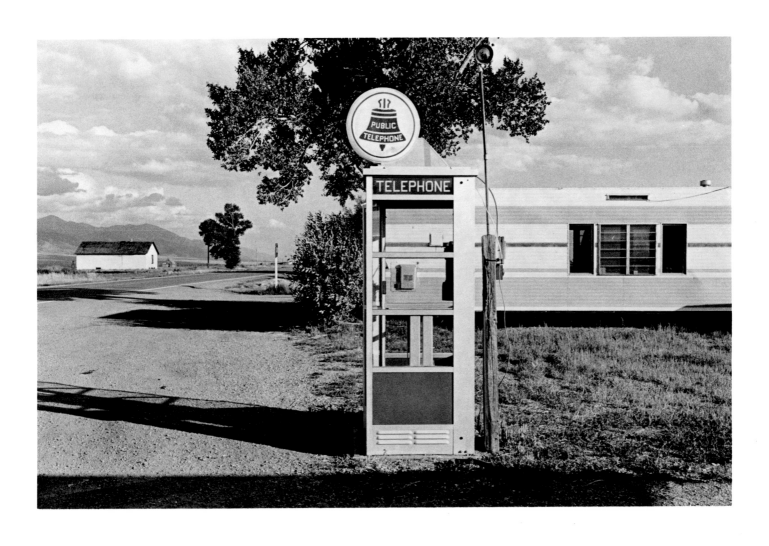

TOD PAPAGEORGE:

On Christmas mornings my father was a photographer. I remember this because the picture-taking was attended by two high-standing lamps which had been pulled down from the attic to wash the tree and living room with enough light for a proper exposure. My sister and I, called to attention, stared ferociously at those awful bulbs, not understanding that even as we sat there, blooming from the ribbons and wrapping paper, we were part of a ceremony; that we were, in fact, its motive.

The camera stood on three legs and had a short bellows for a nose. My father gave it the kind of cautious attention he reserved for stray animals, an attention which was never disappointed, for what the camera returned was always a surprise and a perfect gift, coming back in a postdated, almost posthumous way as a package of square shining prints. My whole family studied these small pictures, and helped to paste and slip them, corner by corner, onto the wide black pages of scrapbooks. The hot lights, the collapsible box, and even Christmas were forgotten as we laughed at ourselves looking back.

For me, the word *snapshot* is tied in

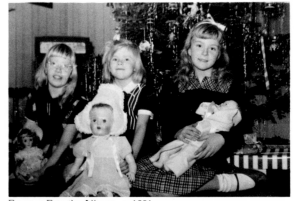
From a Family Album, c. 1951

meaning to the family album, a book which brought to photography a new vernacular form. Like a child's language, this form was locational in its description ("You stand there!"), and could express only what it already understood. This kind of

24

knowledge is simple and strong, for it is from a sense of immediate, communal *naming* that the family album takes its beauty. The graphic audacity which shocks us in frame after frame of these pictures—their haphazard balance and amputating edges—seems also to be the result of this same excited act, but more often is just the mechanical aftermark of an inaccurate viewfinder. For the most part, the family photographer attempted to make the picture's subject its center, but if he or the camera missed, it was no large matter: when pasted in and titled with white ink, all the minor subversion and impingement cutting in from the corner of the frame could be ignored.

The eye which created the family album was the heart's eye, and by its innocence, its very love-blindness, let Swerve and Fracture invade the domestic precincts to transform memento-portraits into flat, half-cocked photographs. If memory was confused by the camera's report, the discrepancy was unremarked. The picture had been taken, and love answered.

It's unarguable to say that every one of us has been moved by the beauty of what I have called *snapshots*, but for photographers they are charms and proverbs, and like lightning or wild strawberries, sense affairs that strike but do not hold. They have a prototype—the nineteenth-century studio portrait—just as they are now being suggested as a prototype for the small-camera photography which developed in the 1930s. However, this is complicated by the fact that while there can be gestural correspondences of form between the two, practice tells me that sight and discipline have made a sure severing where ligature only *might* have been, and that album

photography has had no more influence on the main tradition than any folk art appears to have had on its own particular

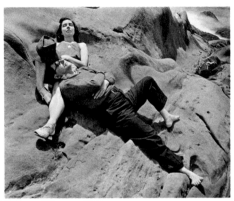
Edward Weston, 1939

medium. Parenthetically, I should say that, for me, men like Walker Evans and even Edward Weston have been closer to the direct celebrating spirit of our anonymous box camera photographers than Kertész, Cartier-Bresson and later masters of 35mm photography.

After I bought the Leica in 1928 I went completely crazy. I could finally express all that had been dormant; with this machine

André Kertész, 1929

I could photograph everything I wanted. André Kertész, March 8, 1974

André Kertész, and then Henri Cartier-Bresson, were the first photographers to

understand that the Leica was more than a fine toy. For Kertész, the camera was a key to those hours and corners which, before, had more or less eluded him; it justified his sense of what he had done, and extended it to what he had known *should* be done. Cartier-Bresson more nearly seized upon the *process* implicit in the Leica's ease of handling — that it could trap and take the world at the speed of a pulse — for the film the camera used, a ribbon of thirty-six uncoiling frames, was sprung by a rapid shutter able to stop and stop again a face or body in its turning. Unlike the box camera's, the Leica's frame had no natural center, but was a wide field half again as long as it was high, and shaped to the eye's horizontal seeing. Practice came to suggest that the pictures this small camera made would take their eloquence from grace and suddenness: that being fitful in their ability to render a discursive description, their suc-

Henri Cartier-Bresson, 1933

cess would depend as much on the weave and brilliance of design as on any instruction they could give about the true gravity of the facts they contained.

It should be remembered that the Leica employed cine film — that, in some sense, it was an invention spawned by motion pic-

tures — and that Griffith, Chaplin, Keaton, Dziga Vertov and other swaggering *boulevardiers* had already redeemed and returned the life of the street to poetry. I think that such men were the true antecedents for those photographers who so passionately took to the streets after them, for in their films they not only rediscovered the crowing beauty of common facts, but also gave a figure for a new dance.

I had just discovered the Leica. It became the extension of my eye, and I have never been separated from it since I found it. I prowled the streets all day, feeling very strung-up and ready to pounce. Henri Cartier-Bresson, Introduction to *The Decisive Moment*

For a photographer watching in the street, the dramas there are incalculable, oblique, and continually rising. A sidestep, handshake, kiss or slow goodbye are met-

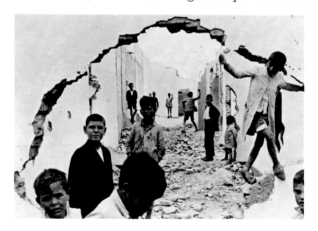

ric shifts, sprung rhythms set against the beat of walking. However, *any* disciplined photographer, whether he works with a stutter-stepping Leica, or under the black hood of the view camera, is pressed by the same problem: to establish an exact physical position in relation to a subject. This

subject will be as various and *discovered* as the perceptions of different photographers (and cameras) make it, but the act of gesture or command which traps it is always the same one, and is directed by

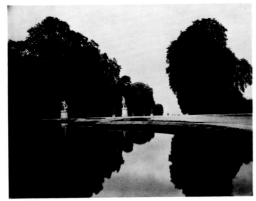

Eugène Atget, c. 1900

sight. This is important, for what serious photographers share is guild-deep and much stronger than those differences of subject matter reviewers commonly lunch on. For example, Robert Frank and Atget, however separate their routes and ambitions, stare faultlessly: the verb is one; the shared motive, seeing; and the distance between the two photographers no greater than adjectives can measure.

Cameras are like dogs, but dumb, and toward quarry, even more faithful. They point, they render, and defy the photographer who hopes. Photography investigates no deeper relief than surfaces. It is superficial, in the first sense of the word; it studies the shape and skin of things, that which can be seen. By a passionate extension of this, its most profound meanings have to do with immanence, the indwelling grace of what Zen calls our ten thousand facts. This is not transport, or celestial transcendence, but that more footed joy and grief found near any clear sighting of the world.

However, I was speaking of cameras

and how they promote themselves, and to continue, will add that "happy accidents" do happen, and probably in direct proportion to the chances the photographer takes. Poets and cooks are blessed by such occasions, and the conclusion seems to be that gifts should be taken and, if possible, learned from. Training may bring the photographer's eye to a kind of secular awareness, but the body, which moves with it, also forms and sees with its own singular pressure. Athletes know this, and probably anyone else who seriously practices.

[*In 1930 Walker Evans*] *told Lincoln Kirstein that the possibilities of the medium excited him so much that he sometimes thought himself mad.* John Szarkowski, Introduction to *Walker Evans*

From wherever it begins, a photograph ends as a cupped abstraction: the thing capsized, stripped, and projected as an

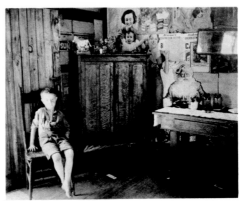

Walker Evans, 1936

image. If made well, it will give its own shape of delight and, at the same time, be tempered as conclusively as steel. The game is the old one of form set against the specific charge and demand of content. Photographers do not expect others to understand this, but for them the process they use is prodigal, addictive, and maddening.

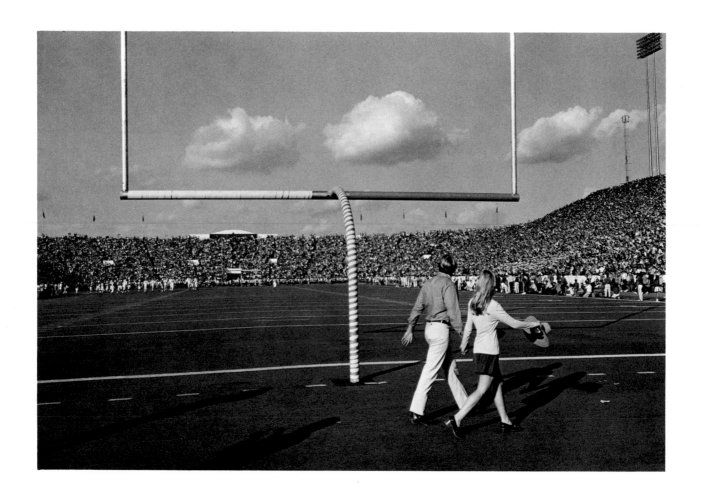

TOD PAPAGEORGE

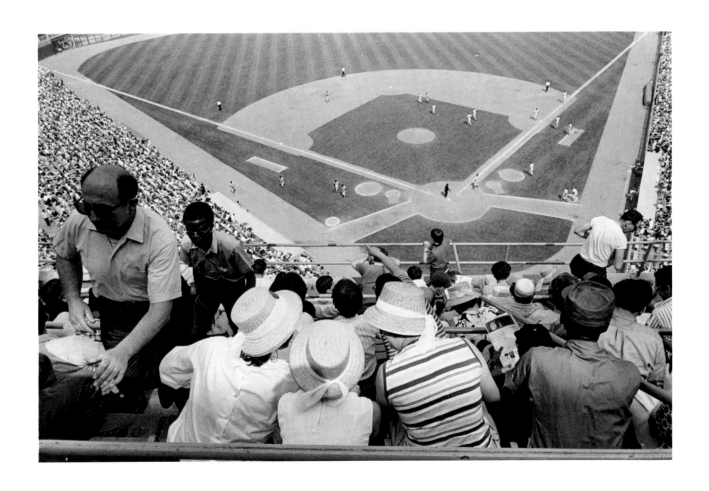

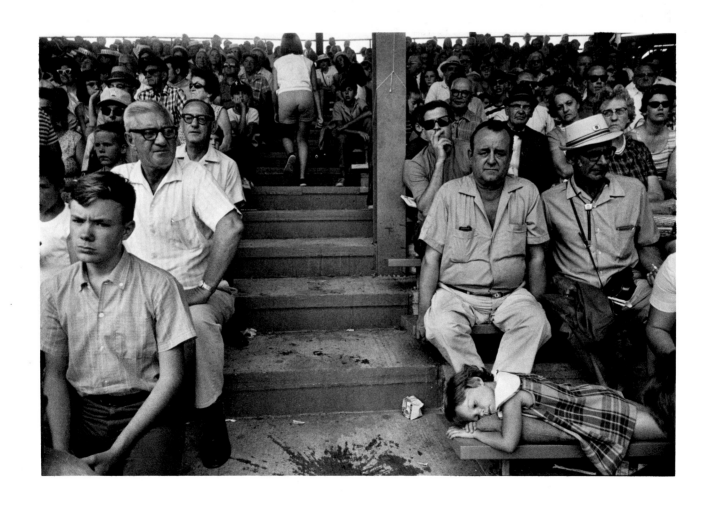

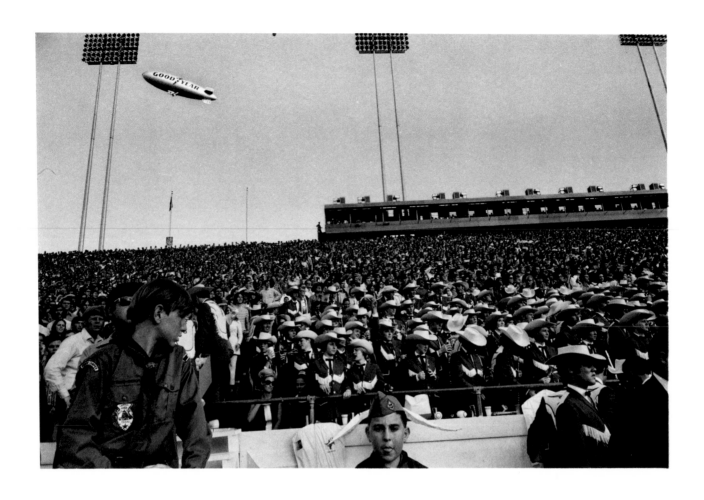

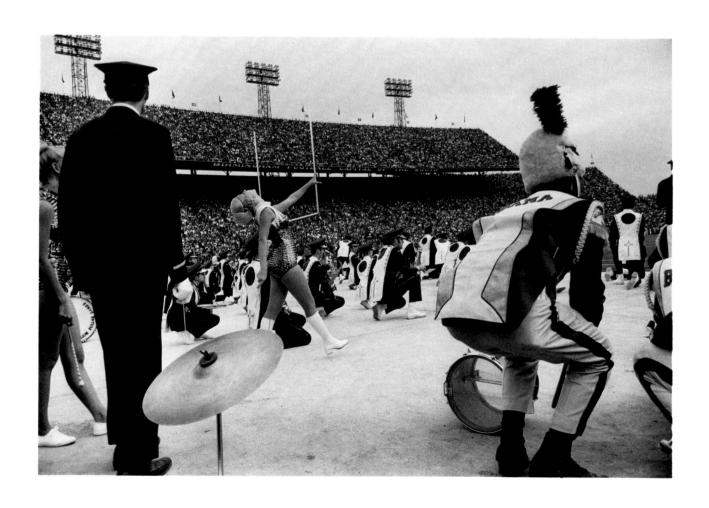

These photographs were made from a moving car with little time for contemplation or control. They might be called pictures about the act of photography. They are the recognition of the photographic presence of a place or moment, and like snapshots they accept the accidental conjunctions and chance incidents occurring in the frame. While they were made in the swift and artless manner of the snapshot, it is their cumulative formality and their insistent vision that make them photographs.

Proust wrote, "The motor car . . . destroys our conception of position in space as the individual mark, the irremovable beauties . . . it gives us on the contrary the impression of discovering, of determining for ourselves as with a compass, of helping us to feel with a more fondly exploring hand, with a finer precision, the true geometry, the fair measure of the earth."

JOEL MEYEROWITZ

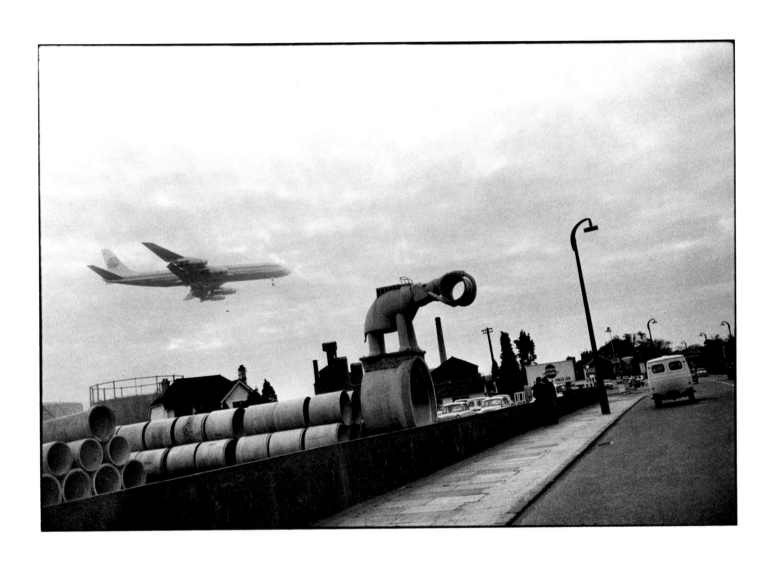

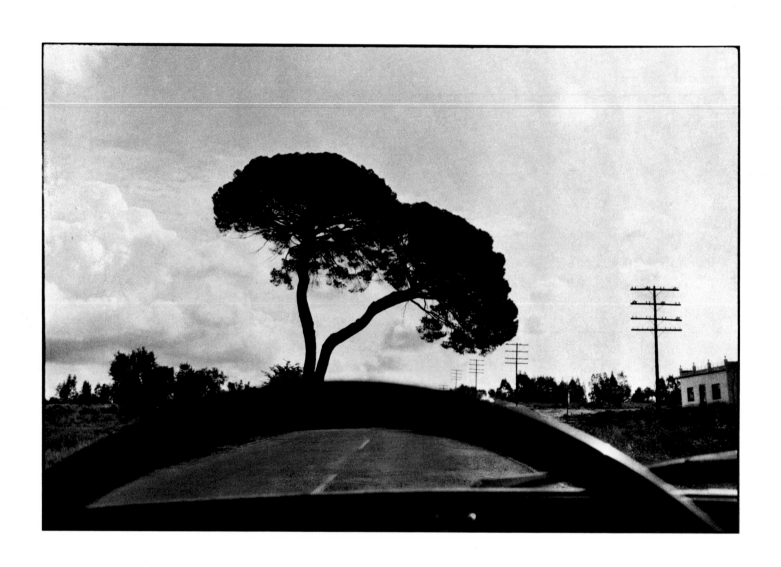

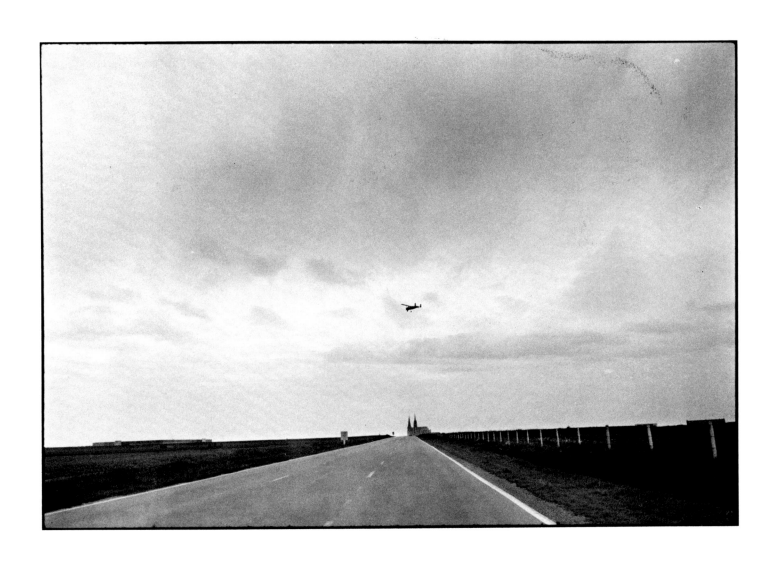

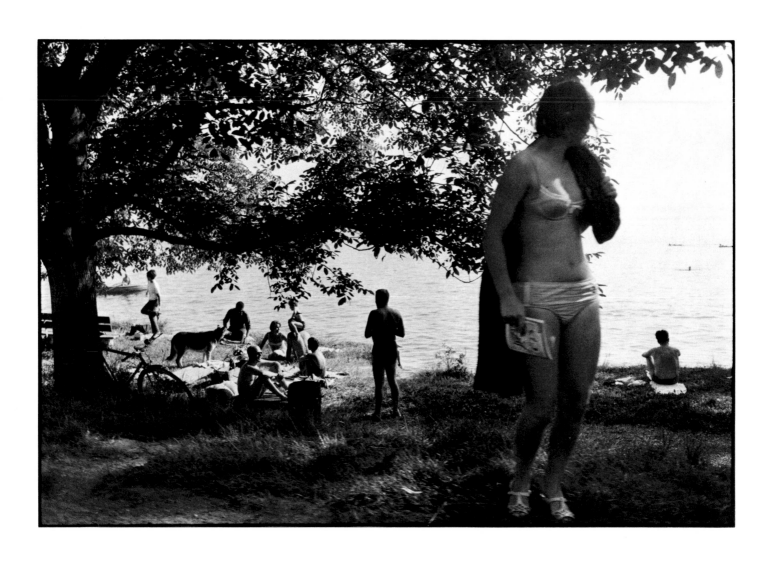

PAUL STRAND:

Paul Strand's comments on the snapshot were taped during his trip to New York in 1973.

I have always taken the position that the word *snapshot* doesn't really mean anything. To talk about it you almost have to begin by asking: When is a snapshot not a snapshot? When is a photograph not a snapshot? The basic aspect of the question, I think, lies in the development of photography itself.

I always think the material aspect of things is the real basis from which the whole development of photography or anything else flows. For instance, just imagine what the difference must be between, let's say, the first recordings that Edison made of sound, the first phonograph, and the present methods of recording. The difference doesn't lie in anything but the development of the actual material, the development of electricity and of sound recording. Photography developed likewise. As photography developed the shutter developed, the speed of the lens de-

veloped, and the speed of photographic emulsions increased. These were potent influences on what the photographer could do.

To be able to make photographs quickly is a highly interesting and desirable technical advance in the whole photographic structure and invaluable to all kinds of photographers. It has certainly been remarkable from the point of view of bringing thousands upon thousands of people into photography. And it has been invaluable to the vast millions who make photographs for their own pleasure and for their own albums. And it has enabled the artist in photography to do things that D.O. Hill found impossible to do, though we should remember that his portraits have never been surpassed. Hill couldn't do it because he didn't have the materials—that's all.

The snapshot, so called—I'm afraid I'm always going to have to add "so called"—is also more or less synonymous with the

hand camera. I used a hand camera around 1915 when I first started photographing in the streets of New York. First I had a 3-1/4 × 4-1/4 English Reflex and after that a 4×5 Graflex and finally a 5×7 Graflex in the Southwest after 1930. That 5×7 became my basic camera. And I have been using a small hand camera for the last ten years as an accessory. Why? Because I want, again, the mobility that only a hand camera can give. The minute you have to set a camera on a tripod the whole way of working is changed. The way of seeing is changed because by the time you get it on the tripod, whatever it is that was happening is gone. Also, if it concerns people they become self-conscious and they change. So the small camera is extremely valuable because it lets you work fast by seeing fast and because it uses materials that will record something in a relatively brief time.

The man who really showed what could be done with a 35mm is Henri Cartier-Bresson. I don't think anybody has added to that since. I don't think anybody has done anything with a 35mm that he didn't do. He uses the camera precisely. In fact, he has a remarkable knowledge and sense of organizing picture space within the split second. I don't think that he has any afterthoughts at all. He used to say, and I imagine that he adheres to it quite largely, that he never crops his pictures. So there is no finding something afterwards. It's all there in that tiny little negative.

When I started photographing in the streets of New York, I was certainly conscious of doing something different from the Photo-Secession. Something that I didn't think anybody had done before. I was interested in applying the knowledge gained from my abstract experiments

with the bowls and all those things to life as it went on outside. In, let's say *Wall Street* and the *White Fence* and the *Blind Woman*, the best examples of that period as far as my work is concerned, I used the English Reflex with 3-1/4 × 4-1/4 glass plates. For *Wall Street* I stood on top of the Treasury steps, which were right across from the Morgan building. I had, of course, already decided exactly what I wanted to do there. It wasn't just that I was wandering around and I happened to see something like that. I went down there with a camera in order to see whether I could get the abstract movement of the counterpoint between the parade of those great black shapes of the building and all those people hurrying below. Also, perhaps I had the less conscious consideration that these office buildings swallowed up the lives of those people as they came rushing to work. Everything depended for the success of that photograph on stopping the movement of the people. Awful things can happen in photography when you photograph moving objects—especially people. You can get one-legged people by the accident of the one leg being behind the other leg. It is not completely controllable. I don't think anybody's eye is that sharp. Especially if you have as many people as that walking. I consider in a way it's a very lucky photograph. I could just as well have failed.

In *Wall Street* and in such photographs as the one of City Hall Park and the one at 42nd Street and Fifth Avenue I was trying to re-create the abstract movement of people moving in a city; what that kind of movement really feels like and is like. All these photographs were conscious experiments of that kind. They required a technique which could only be described as a

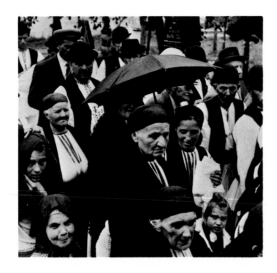

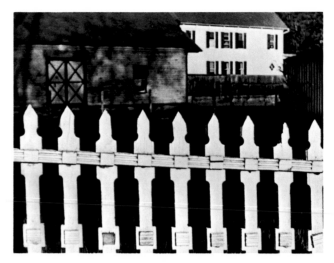

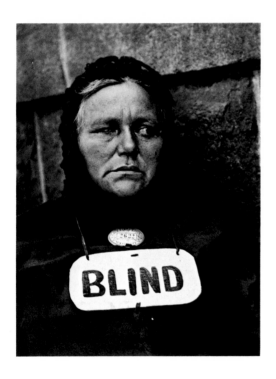

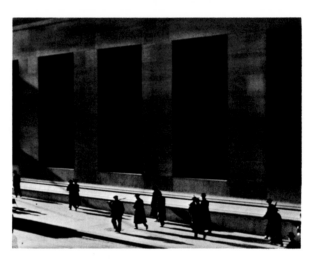

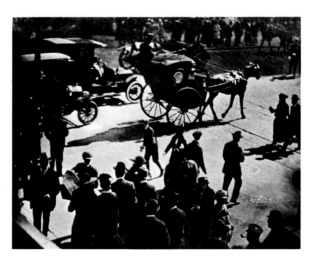

above: Rumania, 1967, and *Blind Woman*, 1916

right, top to bottom: *The White Fence*, 1916,
Wall Street, 1915, *Fifth Avenue*, 1915

snapshot. If you want to use the word *snapshot*, it was a snapshot. When I asked, "When is a photograph a snapshot and when is it not a snapshot," you might say it is a snapshot when it becomes necessary to stop movement. These photographs involved having really enough film or plate speed and shutter speed to make it possible. If it had been a question of a one-minute, two-minute, or three-minute exposure, it would have been impossible. The only way you can stop movement is by an exposure short enough to do that. That may not be more than one twenty-fifth of a second. Any photograph that stops movement can become a snapshot. And you can pick your decisive moment in any subject. You can find a Cartier-Bresson decisive moment in a landscape when the clouds and the landscape and all the rest move together, function together.

I'm really amazed every time I look at *Wall Street* how I did stop the movement because, as I recall, the Weston speed of those plates—ASA they call them now—couldn't have been more than between 12 and 16. The whole development of photography from there on out increases the speed of photographic emulsions—now the common speed is ASA 400—and the speed of the lenses has changed from f8 to f1.2. All this makes for an expansion of the photographic means. It enables people to take a very, very different approach to reality; a different approach to the world around them with a camera.

So you see, the whole concept of the snapshot has to be looked upon in a very broad sort of way. If you want to use the word *snapshot*, you should not use it contemptuously. *Snapshot* should not be a derogatory word. The snapshot is the result of the scientific development of photogra-

phy, and all developments should be welcomed and used with sensitivity. The snapshot has nothing at all to do with amateurism or casual photography. It can be used by many people for many different reasons; by amateurs and by professionals, and also by artists. There is no one answer to the question of how to photograph. There are many ways, and there are many ways to use the materials that have become available.

You see, the extraordinary thing about photography is that it's a truly popular medium. Millions of people photograph. And when Eastman developed the slogan "You press the button and we do the rest," that was not just an advertising device; it was true, and it has become even more true. Today you have built-in exposure meters and all kinds of things to make photography almost foolproof. But this has nothing to do with the art of photography even though the same materials and the same mechanical devices are used. Thoreau said years ago, "You can't say more than you see." No matter what lens you use, no matter what the speed of the film is, no matter how you develop it, no matter how you print it, you cannot say more than you see. That's what that means, and that's the truth.

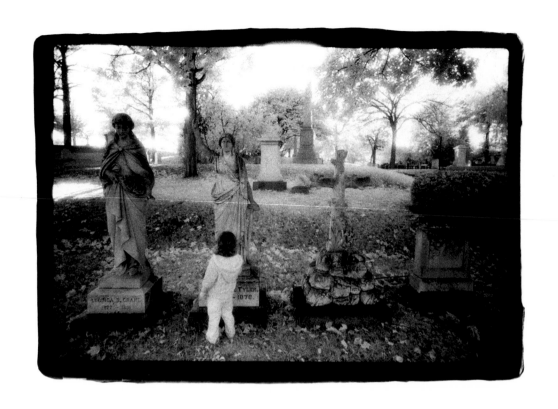

GUS KAVAFAS

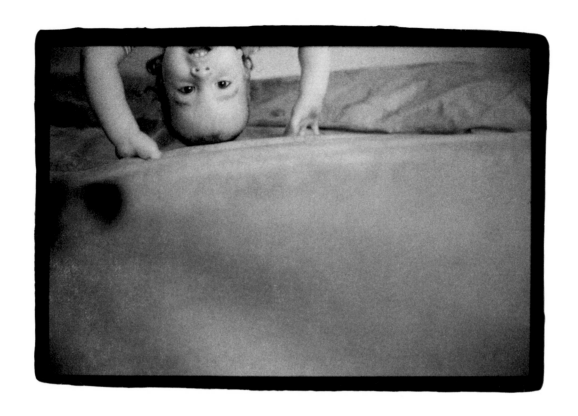

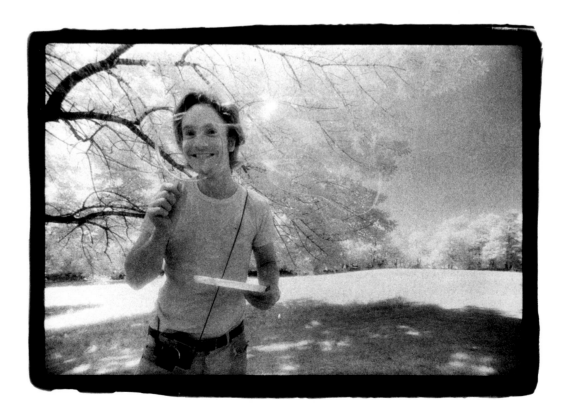

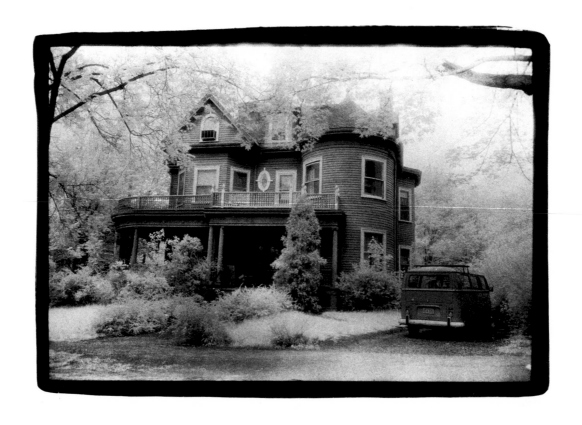

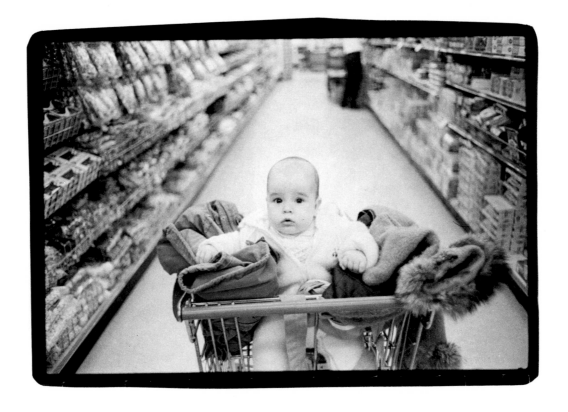

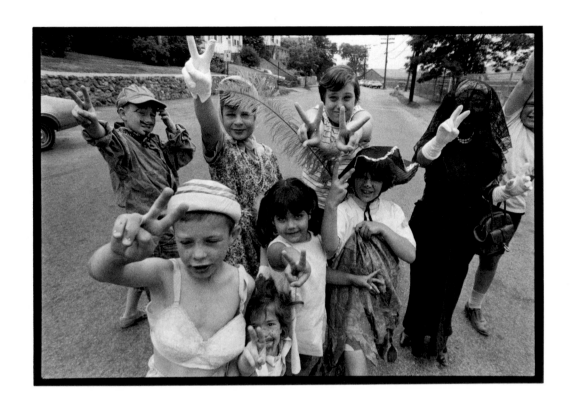

I grew up in Arlington, Virginia. As a kid, I did what I was told. I started photographing when I was twenty-one. At first I photographed mostly people. Now I am twenty-eight.

The photographs in this portfolio were taken in southeastern Ohio with a Diana camera. It cost about $1.50. It is a toy camera that works well. The company also makes a cheaper model that squirts water when you press the shutter. I have developed my own method of hand-holding, sometimes shooting with my eyes closed, using the zone system, dreaming, using five different types of film.

NANCY REXROTH

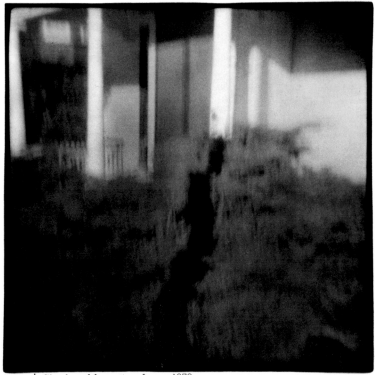

Pillar & Shadow, Muscatine, Iowa, 1973

These photographs are part of a group of images I call *IOWA*. They are my twenty-year-old memories of an Iowa I visited when I was a child. For me, a photograph of Iowa doesn't necessarily have to be taken in Iowa or be about Iowa. Iowa is flat and clean and has a lot of sunshine. In dreams and memories it becomes distorted. Dark evenings, hot-cold sunlight, diffused windows and hallways. The Ohio cities of Pomeroy, Coolville, Gallipolis, and Shade are in Appalachia. Hills, isolated houses. Things are personal from neglect. Through the Diana they become memories of a place I might have been before.

The Diana is made for feelings. The Diana images are often like something you might faintly see in the background of a photograph. Strange fuzzy leaves, masses and forms, simplified doorways. Sometimes I feel as though I could step over the edge of the frame and walk backwards into this unknown region. Then I would keep right on walking.

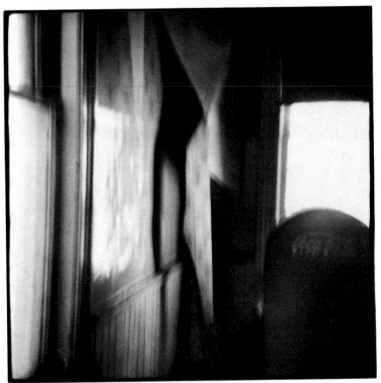

Pomeroy, Ohio, 1971

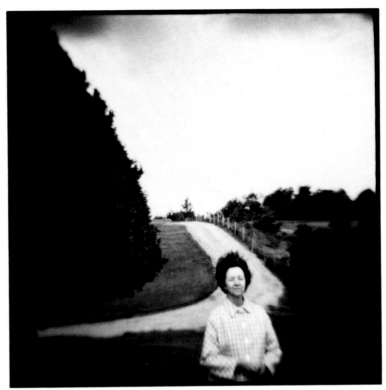

My Mother, Pennsville, Ohio, 1970

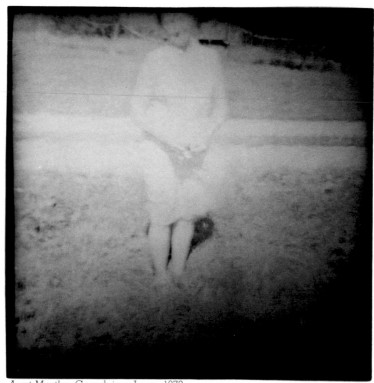

Aunt Martha, Grandview, Iowa, 1973

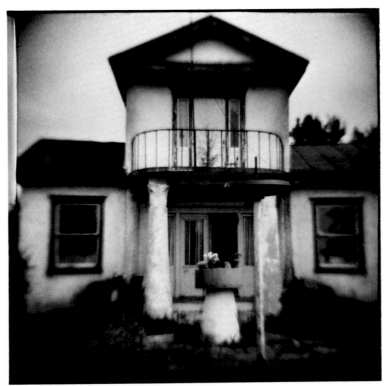

Pillars & Flowers, Manassas, Virginia, 1972

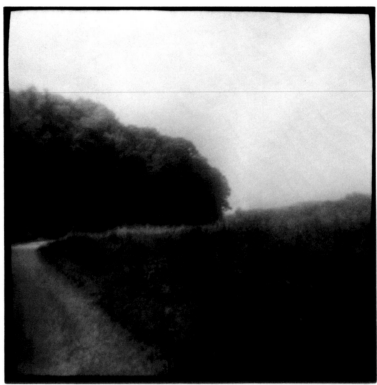

Mountain Route 50, Albany, Ohio, 1973

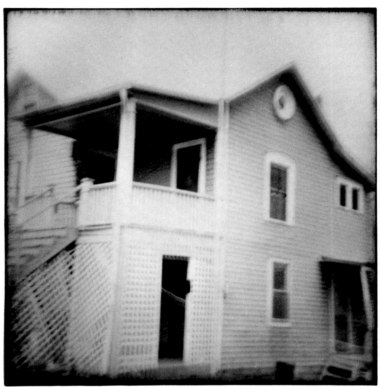

House with Melting Roof, Pomeroy, Ohio, 1971

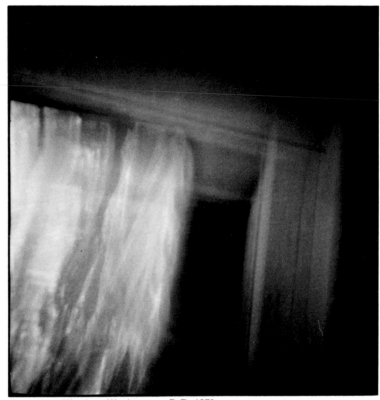

Streaming Window, Washington, D.C., 1972

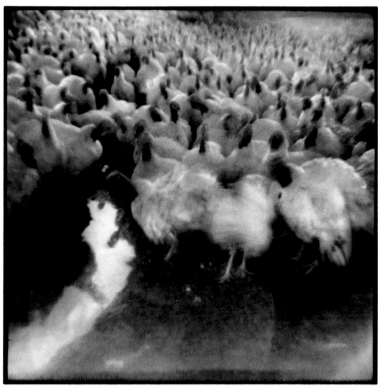

Turkeys Advance, Albany, Ohio, 1973

STEVEN HALPERN:

Souvenirs of Experience: The Victorian Studio Portrait and the Twentieth-Century Snapshot

There is a daguerreotype in the Boston Museum of Fine Arts taken by Josiah Hawes of his wife and child that could easily be mistaken for a snapshot. Informal, intimate and seemingly unposed, it stands in sharp contrast to the studio portraits that make up the rest of the collection. The existence of this picture indicates that the basis for the snapshot was already available when the first daguerreotype portraits were made. The family by 1850, consisting of parents and children isolated from grandparents and relatives, was already a well-developed nuclear institution. However, casual family life was not yet recognized as legitimate subject matter, nor was there a willingness to let the first cumbersome cameras diverge from accepted pictorial standards. It was not until thirty years later that technical innovations in photography and the idealization of the nuclear family allowed the snapshot to begin its rise to dominance.

From the 1840s until the turn of the century the most popular form of photography

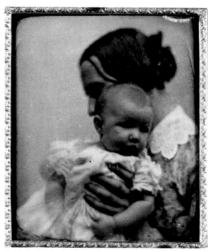

Josiah Hawes, *Mrs. J. J. Hawes and Alice*, c. 1852

was the studio portrait. Almost everyone went to have his picture taken. From the Civil War on, in both urban and rural America the portrait photographer was as common as the local barber.

This interest in portraiture corresponded

with the new and generalized individualism that had triumphed with the French and American revolutions. The vernacular portrait, as in other emerging popular art forms such as the novel, provided a way for the classes which had declared their political existence through the revolutions to achieve a cultural identity: to see themselves as unique individuals.

The Victorian studio photographer based his style on the painted portraits and particularly on the painted miniatures which had preceded the birth of photography by half a century. From the miniaturists he took the oval picture format and the locket case. Like the miniaturist, the photographer placed his subject's face in the middle of the frame one third of the way down from the upper edge. Directly in the center he placed some sort of decorative element: a fancy cravat, an expanse of white shirt or lace, a brooch or ruffled collar. To ensure natural perspective the pho-

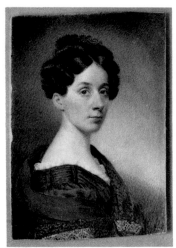

Painted Miniature, 1830 Studio Photograph, c. 1880

tographer set his lens at eye level. To achieve a sense of volume he illuminated his subject's face from above and from one side. The slowness of the early emulsions forced the photographer to place his sub-

In the crudest sense the Victorians were material fetishists. They found meaning, value and even spirit in the possession of things. They worshiped the image rather than the spirit of God. Theirs was an age of public statuary; the monument to Victoria and Albert in London is perhaps their most extravagant production. Theirs was an age of ornamentation. Their extravagance in dress was not due to an urge to hide the body so much as an urge to give it an appropriate form. Each room in the Victorian home was packed wall to wall with objects: rugs, furniture of every style, trophies, knick-knacks, statues, enormous ject in an armchair supported by a headrest. The subject gazed at the camera, his face an image of sturdy solemnity.

Even when faster emulsions became available the same style was maintained. For although the technique was outmoded the aesthetic was not. The result was a traditional portrait indistinguishable in style from the miniaturist paintings.

There is a religious quality to these early portraits. Being photographed was a rite that was carefully performed. Existence itself was embodied in the image, and it had to be presented with the dignity and balanced propriety that the age gave to all its endeavors. Nothing could be left to chance or spontaneity. Being photographed required a serious and ennobling presentation of the self. For the Victorian, a person was what he seemed. The truest incarnation of "being" was found in the features of a face, in the posture of a body, and in the cut of the clothing. There is no movement. Gestures are at a minimum. These pictures portray their subject through the solidity of flesh, through the lines and expressions that are indelibly traced out in their material features.

Chinese vases, antique guns—souvenirs of a materialist existence. John Fowles in *The French Lieutenant's Woman* aptly characterized the spirit of the age by having his pure-bred Victorian hero say, "I cannot possess this forever and therefore I am sad."

Amid the clutter of the Victorian living room, where each thing had a history, the photograph had a special, almost illuminated place. It was the perfect keepsake. It preserved a material image of oneself and one's family. It transformed person to object and allowed for the material possession of one person by another. Portraits were treasured in gilded frames, in jewelry—where they became the jewels themselves—and in albums which encapsulated the family and the world. The photographic album became the gilt-edged bible of a new age, and like its predecessor with its genealogical tree under the front cover, it was passed on to coming generations as an important part of their physical inheritance and history.

In 1878 Charles Haper Bennett discovered how to sensitize dry gelatin plates so that they would produce negatives with an exposure of one twentieth of a second or less. For the first time it was possible to stop action and record the events of everyday life. Following 1880 a series of photographic innovations—hand-held and folding cameras, roll film, the astigmat lens and finally the cheap Brownie camera—made photography available to everyone. Now besides having one's picture taken, one took pictures oneself. This was especially true in America, where culture leaned towards a do-it-yourself, pioneer approach.

From its beginnings the snapshot has had two basic characteristics: a constant focus on family life and an informal, casual style that was consistent with the new freedom within the family and derived from the mobility of the hand-held camera. The Victorian portrait had made the photograph readily available to each family, but while the Victorian portrait concentrated on the individual within the family the snapshot now saw the family as an integral unit.

While a great attempt was made, and continues to be made today, by the home snapshooter to shape the hand camera's vision into the formal, frontal molds employed by the Victorian studio portrait, the recalcitrant hand camera spontaneously and accidentally generated its own informal style. This radically photographic style hinted at visual and cultural truths that were far removed from the stereotypes which gave form to the Victorian portrait. The snapshot began to characterize the family in terms of interaction. No longer did father stand behind and above his family as the ruling patriarch. The snapshot allowed each member of the family to acquire an identity defined by his relationships with others and his physical surroundings. The snapshot could still record the posed moment, but it could also capture the fleeting expression and candidly look at the ongoing life of the nuclear family as it was actually experienced.

The childhood photographs of Jacques Lartigue offer excellent examples of the new form and content of the snapshot. With the intuitive, insightful eye of a highly visual child, Lartigue, at the turn of the century, caught the spirit of the privileged domestic life of *belle époque* France. His photographs have an immediacy and

an accuracy of gesture and detail that until this time was only the province of the novel. The people in Lartigue's photographs are off-guard and natural. They seem to be seen in a passing moment, quickly out of the corner of one's eye. Often the pictures are blurred with movement. The horizon line may be off kilter and the picture

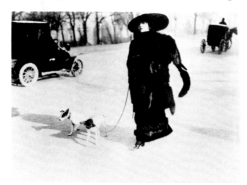

Jacques Henri Lartigue, 1911

edge may bisect the·figures. The main subject is rarely centered and the density of detail extends from edge to edge.

This new vision may be understood as a reaction to Victorian realism. As with other modern art forms, the snapshot appeared simultaneously with the rise of a consciousness of psychology as rooted in family life and alienated from work, and reflected this new consciousness in both its style and content. Like the new novels and paintings, the snapshot presented a world in action, a world caught in passing and filtered through the mind of the observer. This was a world best depicted by stream of consciousness and fragmented perception. This was a world in which appearance and reality were torn apart; where the unposed and unstructured moment became the primary source of revelation.

The family albums of my great-grandparents are filled with serious and severe people looking as if they were bringing their souls to judgment. The snapshots in the albums of my parents show Mom and Dad throwing snowballs at each other in the storm of 1947, there are pictures of picnics, of Aunt Zadie laughing hysterically. The snapshot substitutes gesture for the Victorian attention to feature, and replaces bearing with personal involvement. Where the Victorian portrait suggested perma-

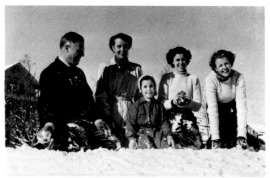

From a Family Album, c. 1954

nence the snapshot suggests transience. They are souvenirs of experience. They are physical keepsakes of a subjective world, whereas the Victorian portraits are physical keepsakes of a material culture.

In the early twentieth century the family became the center of personal and emotional life. As this private world became the dominant focus the snapshot recorded and reified its myths. Today, however, the casual snapshooter has retreated into the idealized, family-centered landscape upon which Kodak has built its ads. This blind retreat has the effect of wearing out the very idealizations themselves. The snapshot is now as stereotyped and as false a presentation of reality as the Victorian portrait had become by the end of the century. Before long the snapshot, too, will be, like its Victorian counterpart, a form of nostalgia.

Snapshots, photographs from family albums, are today's cave paintings, born of the same urges, rituals. I am awed by these urges and what they produce. For the past few years I have collected snapshots from family and friends and put them with my portraits. Another album—a series of biographies—has begun to form. Despite many changes of time and style, the essential expressions of a person's life are always there to be seen. Resemblances to other family members and to ancestors often emerge. It does not matter who made the images.

Pictured here are Marie Baratte, Virginia Powel, my grandmother, cousin Shane and daughter Mary (both at age twelve), Endel and Tõnu Kalam, my grandparents and, again, my grandmother.

WENDY SNYDER MACNEIL

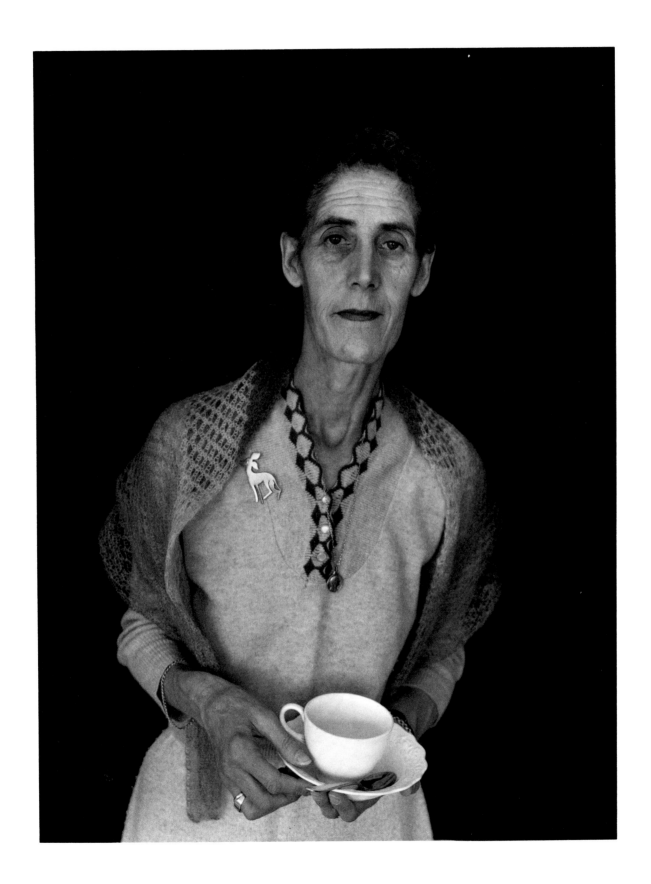

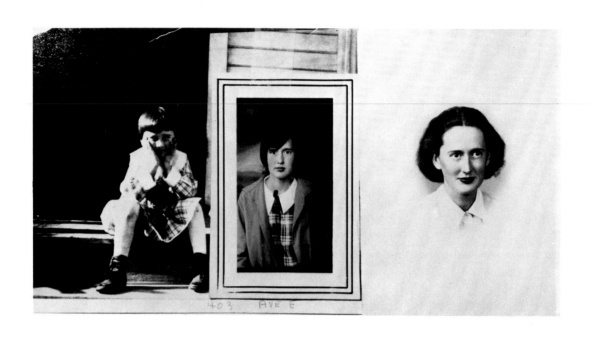

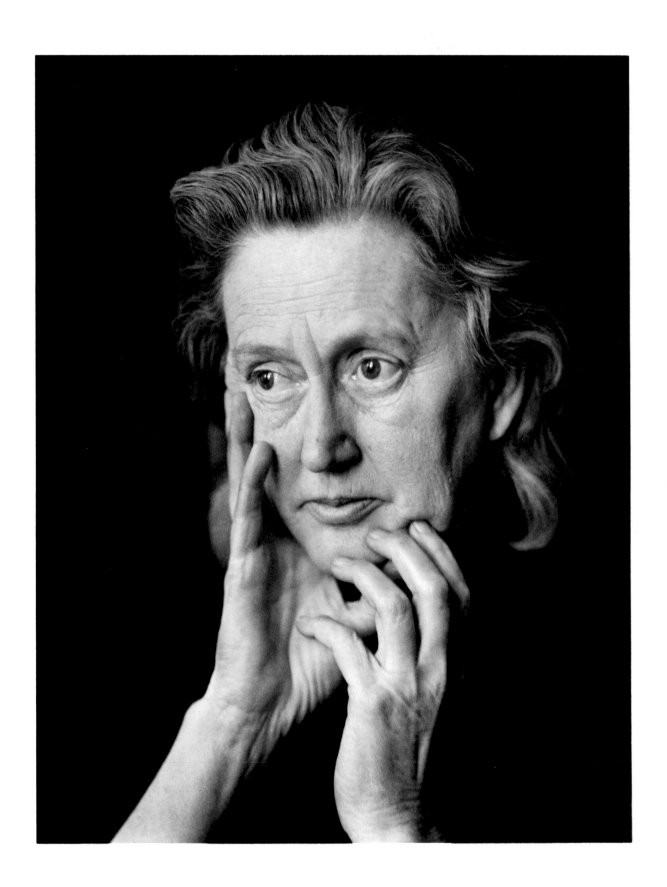

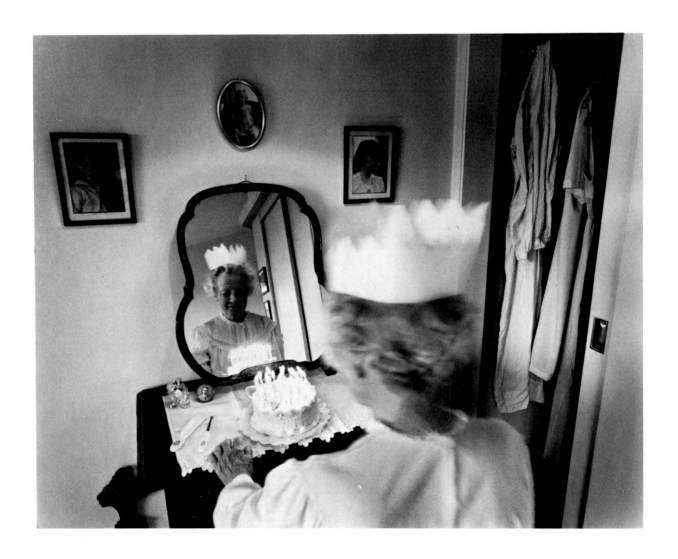

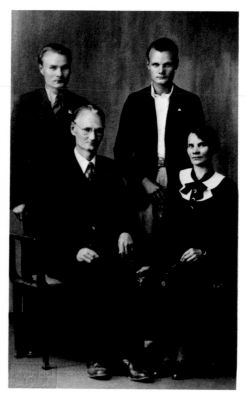

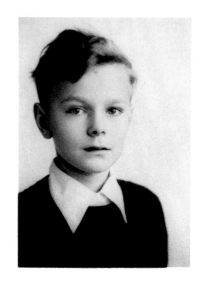

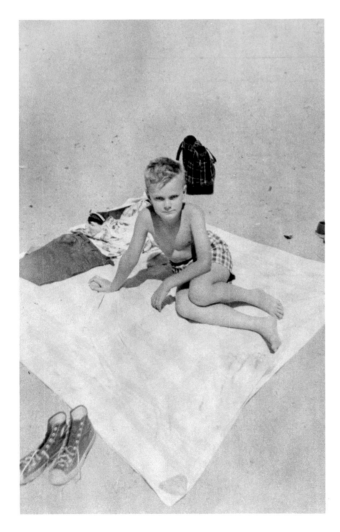

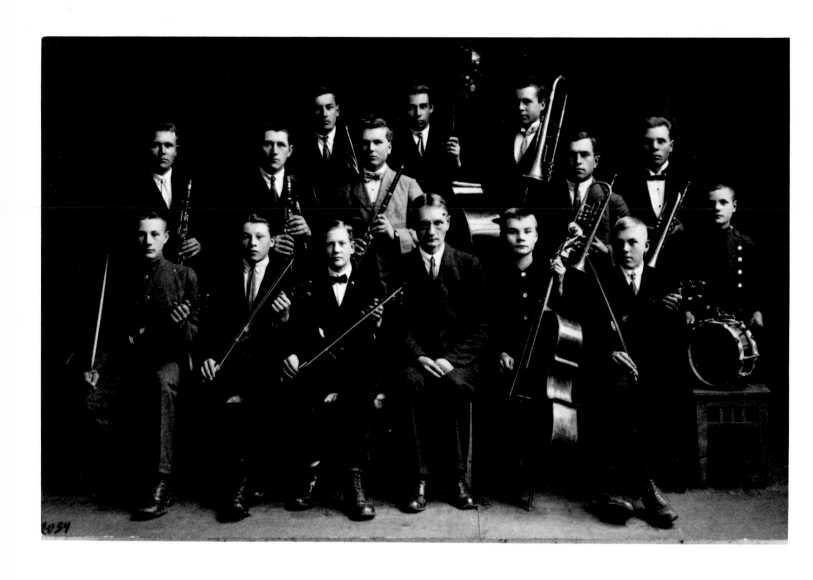

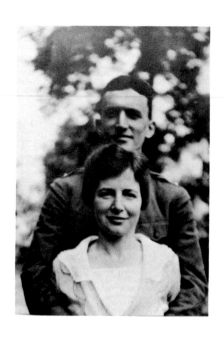

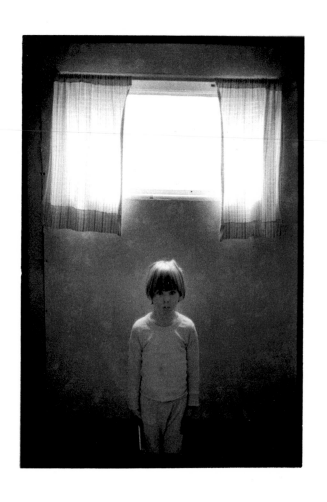

RICHARD ALBERTINE

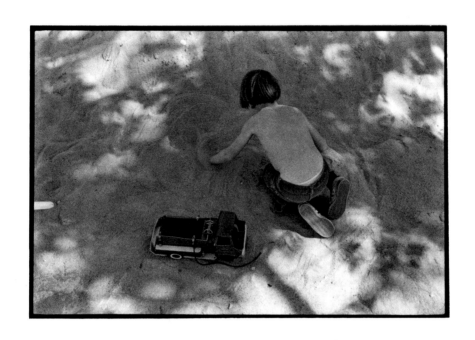

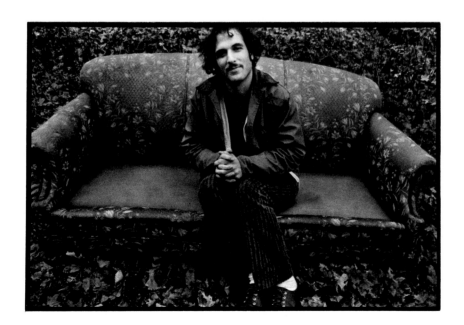

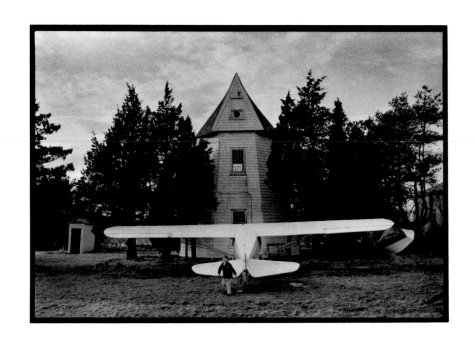

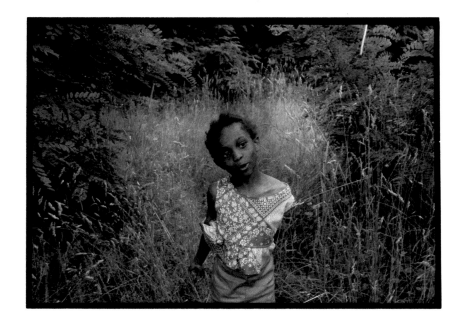

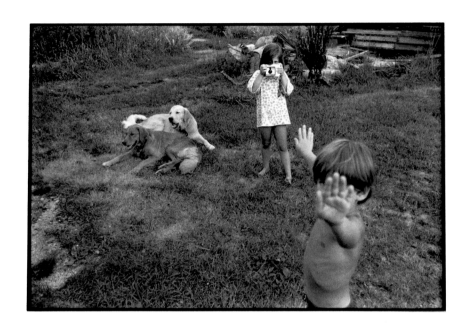

The word *snapshot*, like so many other words used for the purpose of making distinctions or pigeonholing photographs and photographers, is responsible for many misunderstandings about photography.

What photograph is not a snapshot, still life, document, landscape, etc.?

Whether the photographer be Edward Weston, with view camera on tripod, or Robert Frank, with 35mm Leica in hand, or the maker of family album photographs, he only makes still photographs. Regardless of the equipment used or the difference in time the equipment requires, the process is always the same.

This process is Perception (seeing) and Description (operating the camera to make a record) of the seeing.

Neither snapshot, document, landscape, etc., are descriptions of separate photographic aesthetics. There is only still photography with its own unique aesthetic. *Still photography* is the distinctive term.

GARRY WINOGRAND

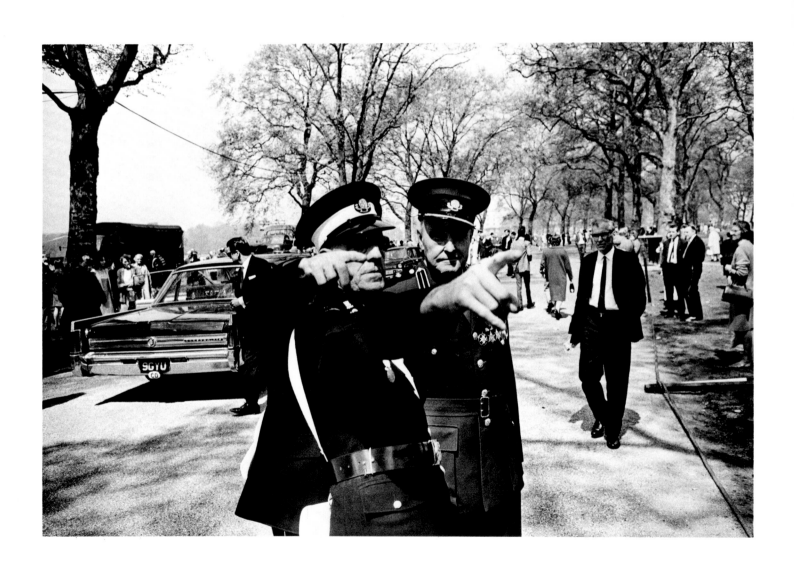

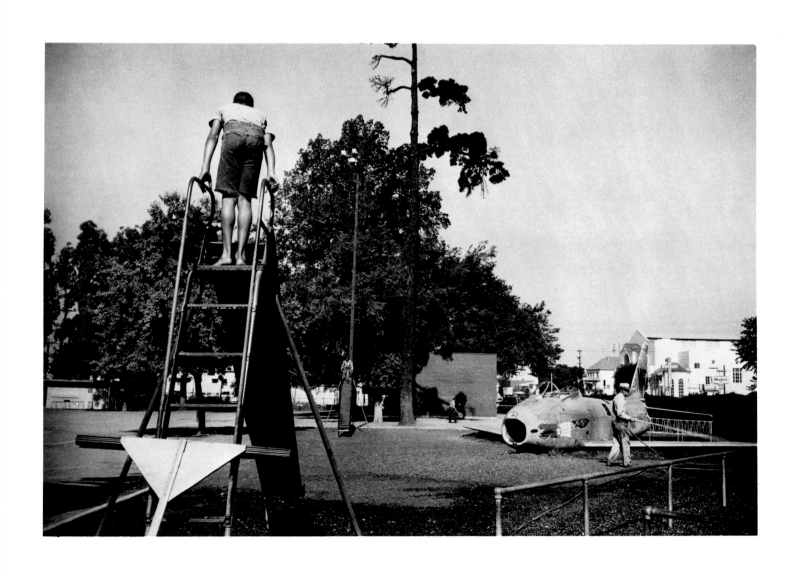

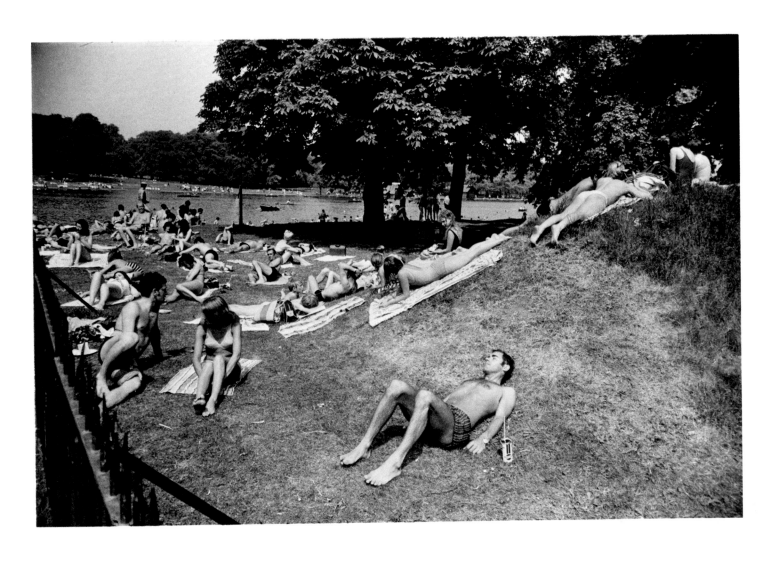

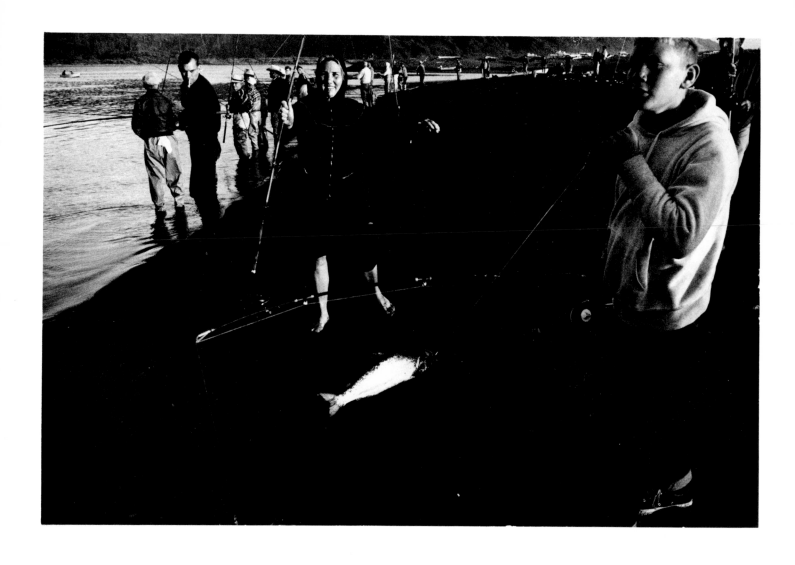

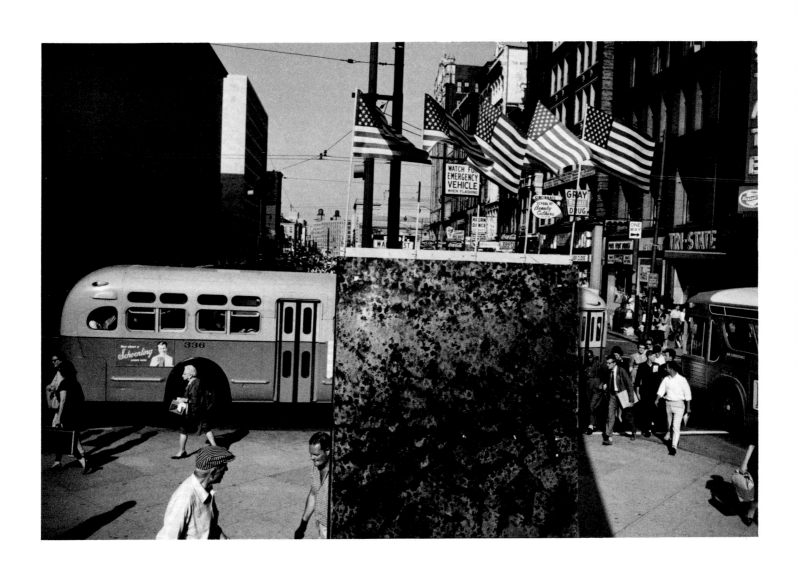

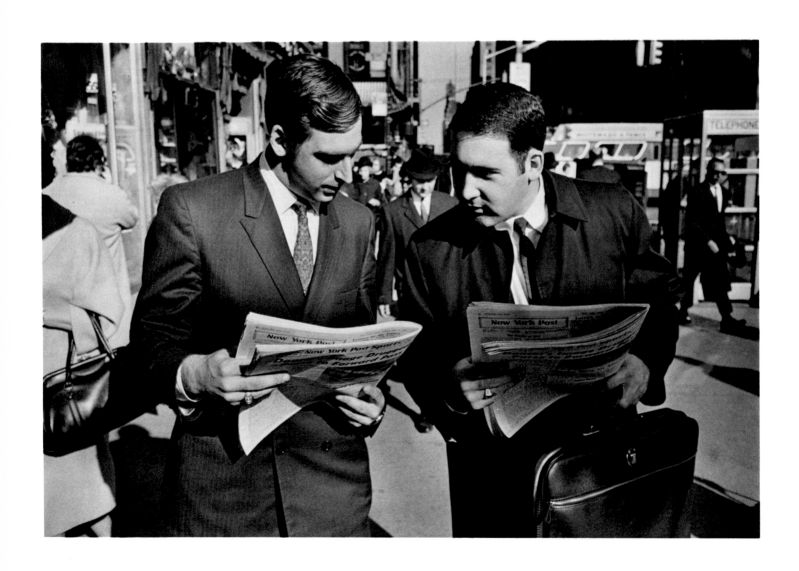

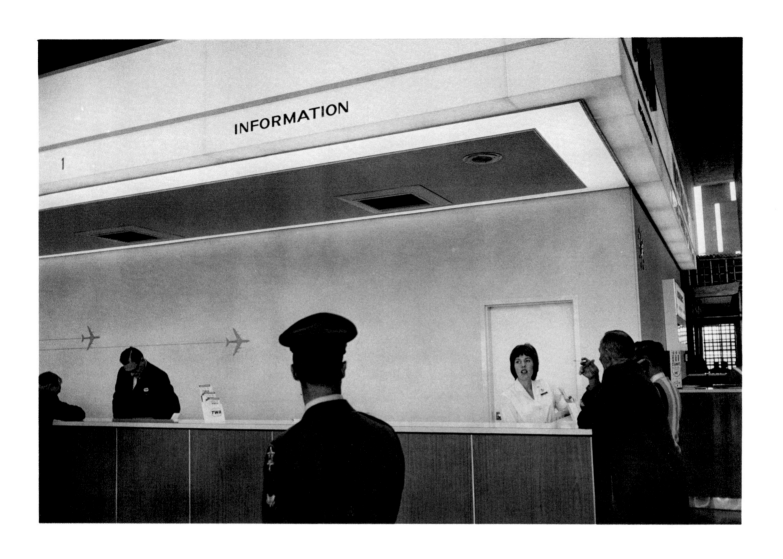

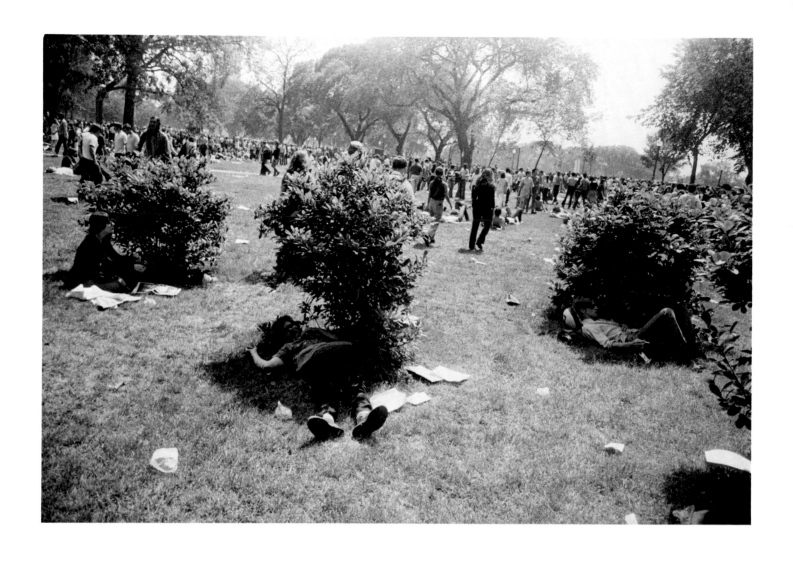

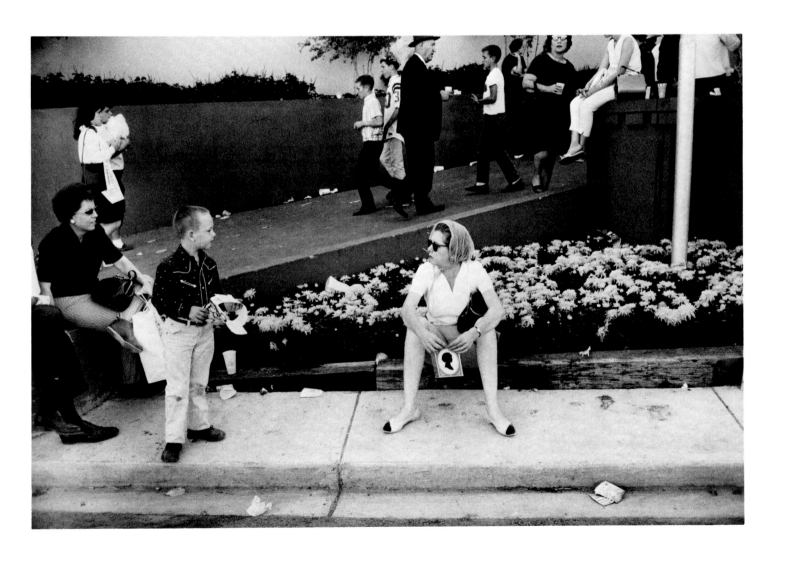

WALKER EVANS:

This essay is an adaptation of two articles written by Walker Evans for *Fortune*: "Main Street Looking North from Courthouse Square," May 1948; and "When Downtown Was a Beautiful Mess," January 1962. It is reprinted here with the permission of *Fortune* and through the courtesy of Mr. Evans.

The mood is quiet, innocent, and honest beyond words. This, faithfully, is the way East Main Street looked on a midweek summer afternoon. This is how the county courthouse rose from the pavement in sharp, endearing ugliness. These, precisely, are the downtown telegraph poles fretting the sky, looped and threaded from High Street to the depot and back again, humming of deaths and transactions. Not everyone could love these avenues just emerged from the mud-rut period, or those trolley cars under the high elms. But those who did loved well, and were somehow nourished thereby.

What has become of the frank, five-a-nickel postcards that fixed the images of all these things? They arrived from the next town up the line, or from across the continent, inscribed for all to see: "Your Ma and I stopped at this hotel before you were ever heard of," or, shamelessly: "Well, if she doesn't care any more than that I don't either. See you Tues." On their tinted surfaces were some of the truest visual records ever made of any period.

They are still around. Tens of thousands of them lie in the dust of attics and junk

Charleston, S.C. Old Market

shops; here and there, files of good ones are carefully ranged in libraries, museums, and in the homes of serious private collectors.

Among collectors of Americana, much is made of the nation's folk art. The picture postcard is folk document. Studying them, it is better to renounce sentimentality and nostalgia, that blurred vision which destroys the actuality of the past. "Good old times" is a cliché for the infirm mind. That said, one can, in effect, re-enter these homely old pictures and situate oneself upon those pavements in downtown Cleveland, Chicago, or Springfield, Massachusetts. One can penetrate those extraordinarily unbeautiful buildings that were, withal, accented with good marble and mahogany and brass. In the street the trolleys are clanging. The air is not entirely free of horse smells. On the sidewalk, striding purposefully forward because his heart is pure, is the young Horatio Alger, determined to gain one more honest dollar than the next cleanly competitor. One's own father's office was on the fifth floor front. Yesterday he paid the bill for your first long pants. Somehow, this can remind you now that there was nothing amusing about first love, juvenile ineptitudes, and early glory.

In the 1900s, sending and saving picture postcards was a prevalent and often a deadly boring fad in a million middle-class family homes. Yet the plethora of cards printed in that period now forms a solid bank from which to draw some of the most charming and, on occasion, the most horrid mementos ever bequeathed one generation by another. At their best, the purity of the humble vintage American cards shines exceeding bright today. For postcards are now in an aesthetic slump from which they are about to recover. Quintessence of gimcrack, most recent postcards serve largely as gaudy boasts that such and such a person visited such and such a place, and for some reason had a fine time. Gone is all

feeling for actual appearance of street, of lived architecture, or of human mien. In the early-century days color photography was of course in its infancy. Cards were usually made from black-and-white photographs subsequently tinted by hand lithography. Yet the best ones achieved a fidelity and a restraint that most current color-photography printers cannot match—notably in

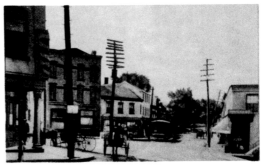

Bank Square, "Five Corners," Fishkill-on-Hudson, N.Y.

flesh tints and in the rendering of patina and the soft tones of town buildings and streets.

But here in the mild morning of almost seventy years ago is "Bank Square, 'Five Corners,' Fishkill-on-Hudson, N. Y.," epitome of Yankee utilitarianism in subjects in execution, and in mood. Made as a routine chore by heaven knows what anonymous photographer, the picture survives as a passable composition, a competent handling of color, and a well-nigh perfect record of place. Indeed, transcending place, it rings a classic note on the theme of small-town main streets.

The postcard field is rich in realism, sentiment, comedy, fantasy, and minor historical document. They invite you to consider them as fondly, as patriotically, or as historically as you like. They satisfied the simple desire to recognize and to boast. We may thank pure corn for some admirable side values.

BILL ZULPO-DANE

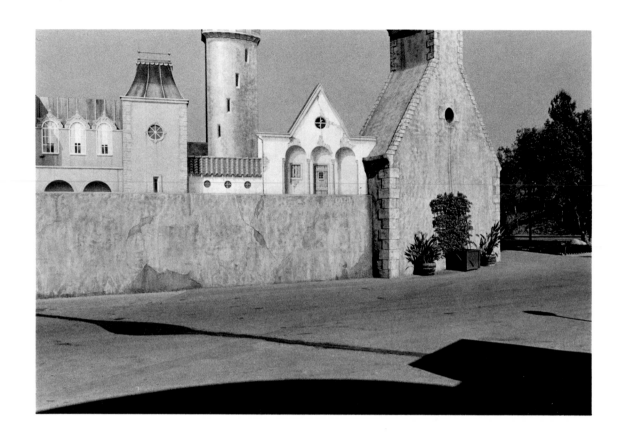

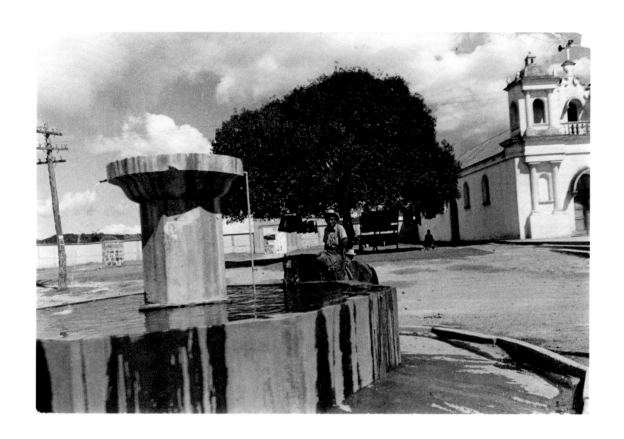

lately
I've enjoyed these
Bach concertos for
unaccompanied
Violin
 Recently
I've enjoyed one of
ten country songs
played from Phoenix
to El Paso
 Bill

José Romero
Berkeley High School
Milvia at Bancroft

Berkeley
Calif.

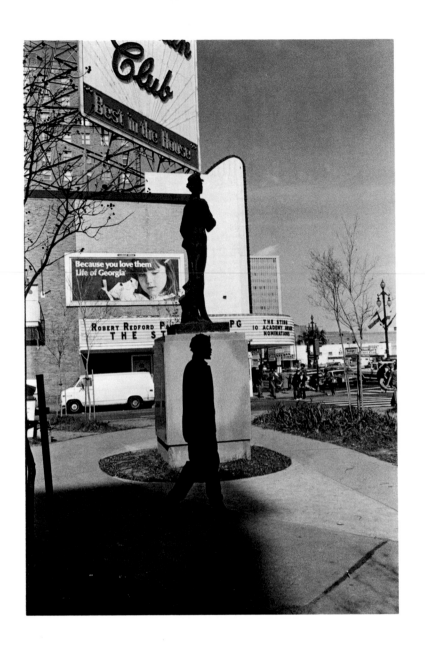

MINER
Monumentalism

now hve aet here for
15 min. thinking what
that could possibly mean
or unmean, and it
sure does might love Bill

P. W. Siler
Fine Arts
Wash. St. U.
Pullman
Wash. 99163

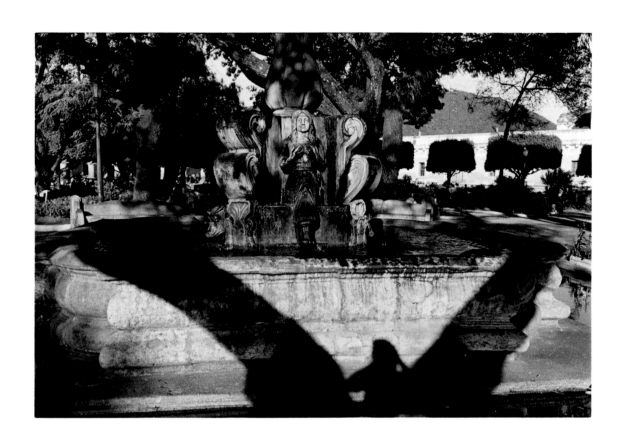

Good luck to all
of us
in the office
on the road
in between

Hello Pat & Tom
are you still there

Bill Mott-Smith
2/20 Sacramento
Berkeley
Calif

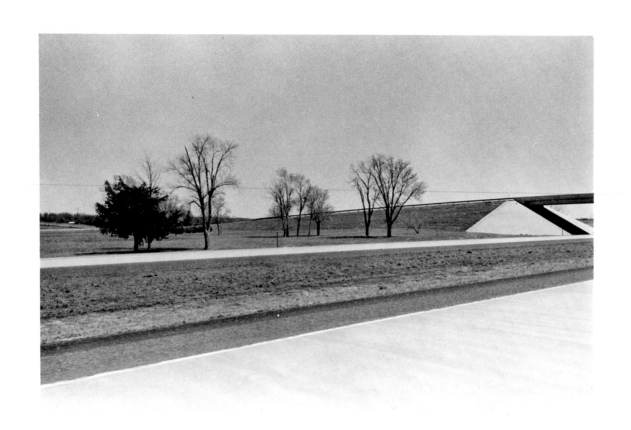

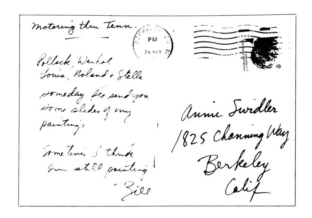

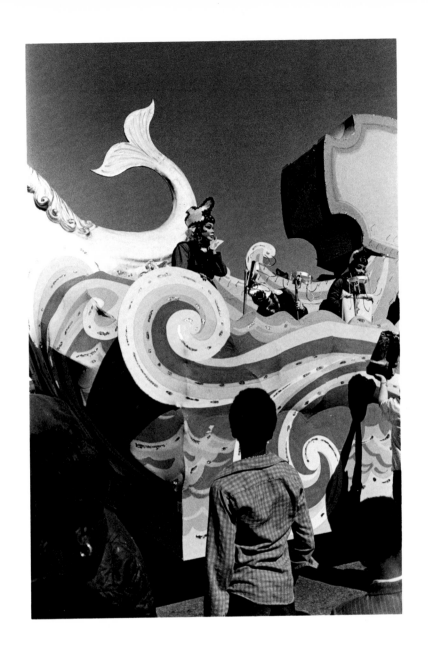

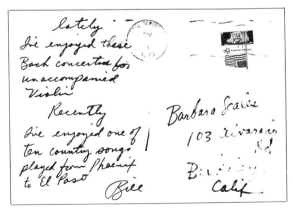

JOHN A. KOUWENHOVEN:

This essay is made up of excerpts from Mr Kouwenhoven's lecture "Living in a Snapshot World." The lecture was the third in the 1972–73 Photographic Points of View Series at the Metropolitan Museum of Art.

Snapshots are predominantly photographs taken quickly with a minimum of deliberate posing on the part of the people represented and with a minimum of deliberate selectivity on the part of the photographer so far as vantage point and the framing or cropping of the image are concerned.

Many early photographs were taken by people whose eyes were accustomed to seeing what well-known nineteenth-century painters and illustrators saw, and who therefore tended to select their subjects with a painter's rather than a photographer's eye. These were chiefly time exposures, not snapshots.

It is the snapshots, not isolated photos made under the influence of the portrait and landscape painters, that best exemplify the basic distinction between painting and photography. Paintings are laborious and costly, and therefore are selective as to subject matter and limited in number. Snapshots are easy and cheap and therefore less selective and far more plentiful.

From a Family Album, 1929

The word *snapshot*, interestingly enough, was originally a hunting term. According to the great Oxford Dictionary, the earliest recorded use of the word was

in the diary of an English sportsman, with the apposite name of Hawker, who in 1808 noted that almost every bird he got was by snapshot, meaning a hurried shot, taken without deliberate aim. As early as 1860 Sir John Herschel, one of the pioneers in photography and the inventor of its name, speculated on the possibility at some future time of being able to take photographs at one tenth of a second, "as it were, by snapshot," but this was a figure of speech depending for its effect upon the reader's familiarity with hunters' lingo. Even in the late 1880s, by which time it appears frequently in articles about the new instantaneous photography, its hunting origins were remembered and acknowledged by putting the word in quotes. But by 1890 the takeover was complete.

Ever since the dry plate became available, people had been fascinated with the idea of shooting pictures surreptitiously. They went about hunting for unposed images to record, taking pictures of people without their knowledge. Indeed, the early hand cameras were generically referred to as "detective cameras."

Unwittingly, amateur snapshooters were revolutionizing mankind's way of seeing. We do not yet realize, I think, how fundamentally snapshots altered the way people saw one another and the world around them by reshaping our conceptions of what is real and therefore of what is important. We tend to see only what the pictorial conventions of our time are calculated to show us. From them we learn what is worth looking for and looking at. The extraordinary thing about snapshots is that they teach us to see things not even their makers had noticed or been interested in.

Even if we ourselves make the snapshot, it contains much we didn't think was worth looking at, at least not until we saw the finished print. For the camera lens is, after all, indiscriminate. Unlike our eyes, it pays equal heed to the light reflected from surfaces of everything within its field of vision. Unless the photographer deliberately interferes with the picture in some way, which amateur snapshooters are not likely to do, the pattern of forms and textures revealed in prints made from a photographic negative is determined by the impartial objectivity of light, not by the photographer's subjective preoccupations and aesthetic choices.

By simply isolating a group of forms and textures within the arbitrary rectangular frame provided by the edges of its glass plate or film, a snapshot forces us to see, and thereby teaches us to see, differently than we could have seen through our own unaided eyes, and also differently than people had been taught to see by pre-photographic pictorial conventions. The pecu-

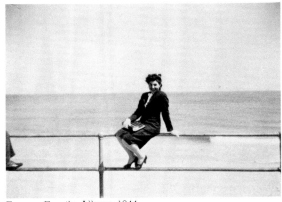

From a Family Album, 1944

liarity of snapshot photographs is that the hierarchy of images within its frame is not ordained by the picture maker. Whatever hierarchy of forms appears in the snapshot is ordained by the indiscriminate neutrality of light. Once people began to look at snapshots they had taken, they therefore

began to see *as significant* a great many things whose significance they had never seen before.

William M. Ivins, in his book *Prints and Visual Communication*, states that "at any given moment the accepted report of an event is of greater importance than the event, for what we think about and act upon is the symbolic report and not the concrete event itself." By the end of the First World War the nonverbal symbolic reports upon which people were willing to act, and about which they were willing to think seriously, were predominantly those made by the camera. But the camera, as the New York *Sun's* art critic had observed,

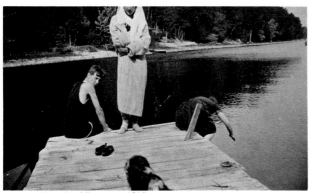

From a Family Album, c. 1912

had "the awkward habit of reporting the significant and the impertinent with equal indifference."

That habit was indeed awkward for those photographers who were exploring the possibilities of photography as an art, who wanted to make pictures expressing their personal vision, their subjective decisions about what is and is not significant. Only a few photographers have ever succeeded in using the camera effectively to that end. The overwhelming majority of all photographic images have been made by people who were content to let the available light determine what was significant.

The cumulative effect of one hundred and thirty years of man's participation in the process of running amuck with cameras was the discovery that there was an amazing amount of significance, historical and otherwise, in a great many things that no one had ever seen until snapshots began forcing people to see them.

I am not making the absurd claim that every snapshot has importance as a revelation, or even that any sizable group of snapshots, like an albumful, is certain to reward you with an awareness of the hitherto unrealized significance of some particular form or surface, or of some class or type of forms or surfaces. What I am saying is simply that because snapshots often revealed impressive significance in things no earlier mode of seeing had enabled man to see, our assumptions about what matters have been profoundly altered.

Before photography, reality was history, and history was very largely something untrustworthily reported that happened long ago. Thanks, or no thanks, to the snapshot, we live in historical reality from the moment we are old enough to look at a Polaroid picture taken two minutes ago.

Willingly or unwillingly we are participants in a revolution in seeing which began when the first snapshots were taken about a hundred years ago. Call it, for want of a better phrase, the democratization of vision.

JUDITH WECHSLER:

As They Were: Celebrated People's Pictures, Tuli Kupferberg and Sylvia Topp, New York, Links Books, 1973. 160 reproductions. Paperbound $2.95. This review generally reflects the influence of E. H. Gombrich. See his "The Mask and the Face: The Perception of Physiognomic Likeness in Life and in Art," in *Art, Perception, and Reality*, Baltimore and London, 1972.

As They Were is a book of photographs of celebrities when they were children. Future politicians, revolutionaries, philosophers, writers, scientists and actors are forecasted in shots of their infancy and youth. Besides recalling a sense of "what they were," these photographs raise some interesting questions about the snapshot and the posed portrait, physiognomy and character, ambience and decorum, projection, association, and recognition.

In the majority of photographs we can recognize the character that has become familiar to us. We catch a glimpse of that quality which is sustained throughout life. Kafka and Castro, Buber and Bella Abzug, Aldous Huxley and Tallulah Bankhead, Lyndon Johnson and T.S. Eliot are distinguishable in photographs ranging from

Lyndon Johnson, age four, 1912

their second year to their teens. The features change over time, become more pronounced, exaggerated. Eyes deepen, the mouth matures; the face transforms through growth and age. Yet there is often a "look" which we clearly discern—a gen-

eral cast of the face, an underlying expression which reflects personality.

The face from its earliest childhood evidences a mode of reflection and reaction, a way of viewing and being viewed in the world. Habitual patterns of reaction leave their mark on the more permanent characteristics of the face. But because these lines

Modigliani, age one, 1885

and markings are not yet incised on the features of youth, the most revealing and effective photographs are those which show the face in motion, at the moment of reaction. Then, the mode of response which will set the face over time, giving it its characteristic look, is revealed.

Because snapshots frequently capture the animation of the face, they are more informative than posed portraits. A person is seen in the context of space and time. Setting creates ambience; sequence of events tells us how the person reacts. Character is revealed by the way of response. Lenny Bruce's smirk amidst a sea of solemn faces at graduation is portentous. How the person smiles or frowns, the relationship between the mouth and the cast of the eyes, the degree of control, of self-consciousness, tell us about the personality.

(As Wittgenstein observed, "If we want to be exact, we do use a gesture or a facial expression.")

Left to assume their own poses, children often reveal what they will become. The pose of the body can be as indicative as the look of the face. Aldous Huxley supporting his serious head on his hand, with legs crossed, ponders with intensity. Fidel Castro at three standing on a chair, one foot forward, projects a steadfast, even stubborn look both in his pose and in his tightly closed yet slightly pouting mouth and fixed eyes. Queen Elizabeth's stance at about seven is unmistakable—unchanged.

In contrast, decorum molds the face like a mask in the posed portrait; external intentions fix the figure. The features are in stasis, telling us little beyond their shape. In a number of photographs—Willy Brandt, Richard Nixon, Mussolini and others—we can recognize the face and not get the essence of who the grown-up person is. In other cases, the set of features are so transformed, as in the photo of Greta Garbo or Joseph Stalin, that the examples appear like contradictions or paradoxes. Certain people one wouldn't be able to identify, because the clues are few and our familiarity with adult visage limited—such as Sholom Aleichem or Sergei Eisenstein.

Necessary clues are given when we can incorporate the setting and the dress into the reading of the image. Jackie Onassis at five on horseback at a riding show, holding rein and whip, looks very much on exhibition. Eugene O'Neill at about seven is seated on a rock looking out over an empty landscape with a pad of paper on his lap. Mae West at six months is lying in a receptive state on a welter of furs. Oscar Wilde poses in a décolleté dress and long curls, like a transvestite child.

When the person is seen in his own environment we get a sense of his world. Franz Kafka as a child of five is pictured in a crowded Victorian room. He holds what appears to be a magician's wand and hat with a vertiginous pattern, as if his striped suit were set in a whirling motion. Kafka glares sideward in a fixed frightened look.

Franz Kafka, age five, 1888

He is a still, observant victim in a fury of encumbering clothes, constraining objects and complicated shapes. Marcel Proust at twelve in a velvet suit with a large bow, white stockings, walking stick in hand, perches on a Baroque balustrade amidst cascading drapes and eighteenth-century paintings, looking like a beautiful, sensitive, self-conscious, precious youth. In these photographs and also in the portraits of James Joyce and Amadeo Modigliani the photograph accurately conveys a visual environment that is simultaneously the mold and an extension of personality and later artistic expression.

Other intellectuals—reflective writers, philosophers, scientists—in this collection withdraw behind the mask of their features in posed pictures. Perhaps as an act of self-preservation, Chekhov, Babel, Buber, Freud,

and Einstein are expectedly serious, intense, reflective. A disciple of Buber's remarked to me, "Was Buber ever a child?" There is a keen sense of personal privacy, a certain inscrutability, to these portraits. In contrast, future public figures, politicians and performers, such as Edward Kennedy, Maurice Chevalier and Fred Astaire, project themselves through the posed picture. The pose is like a role which is inhabited and transformed.

If we were presented with the photographs alone and were asked to identify the individuals, chances are we would not recognize most of them. With the identifying titles below we have little trouble; we bring to the image our associations of the person and project them onto the youthful semblance. E. H. Gombrich has written widely about this phenomenon. He characterized the way we fill in information as "the beholder's share."

I think in some way we would have a more difficult task if the photographs in *As They Were* were accompanied by the image of the known adult personality. Without the later reference we can freely adapt our memory to the childhood picture. We read familiar personality into the promise of character. As Gombrich has observed, "the feeling of constancy completely predominates over the changing appearance." There is generally an invariant in the facial expression discernible from start to finish.

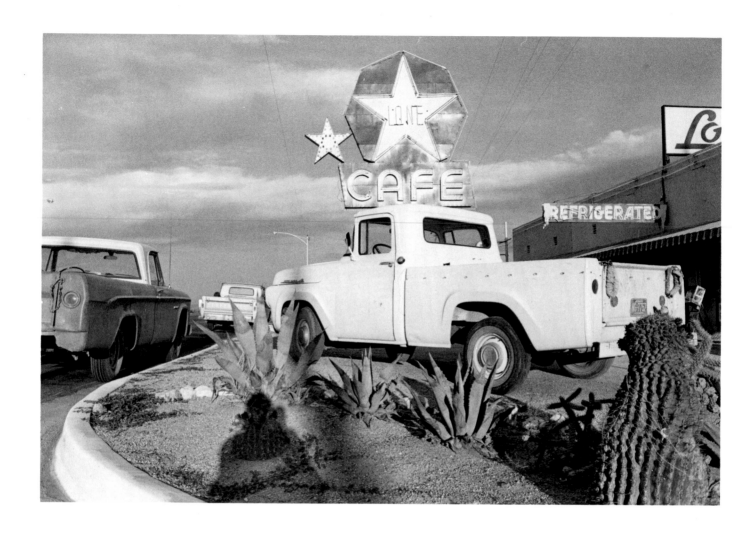

The idea that the *snapshot* would be thought of as a cult or movement is very tiresome to me and, I'm sure, confusing to others. It's a swell word I've always liked. It probably came about because it describes a basic fact of photography. In a snap, or small portion of time,

LEE FRIEDLANDER

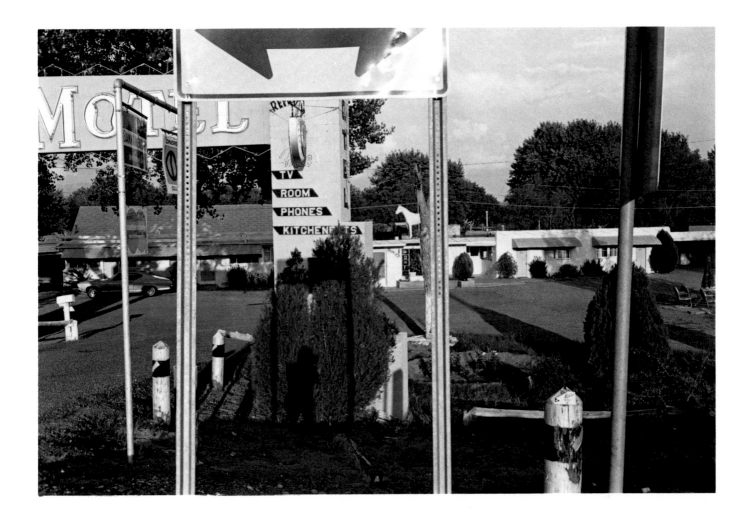

all that the camera can consume in breadth and bite and light is rendered in astonishing detail: all the leaves on a tree as well as the tree itself and all its surroundings.

Whether the practitioner uses small, medium or large format equipment, or whether his concerns and interests are botanical, animal or folks, landscape or street life, etc., the only relevance is the photograph itself. The pleasures of good photographs are the pleasures of good photographs, whatever the particulars of their makeup.

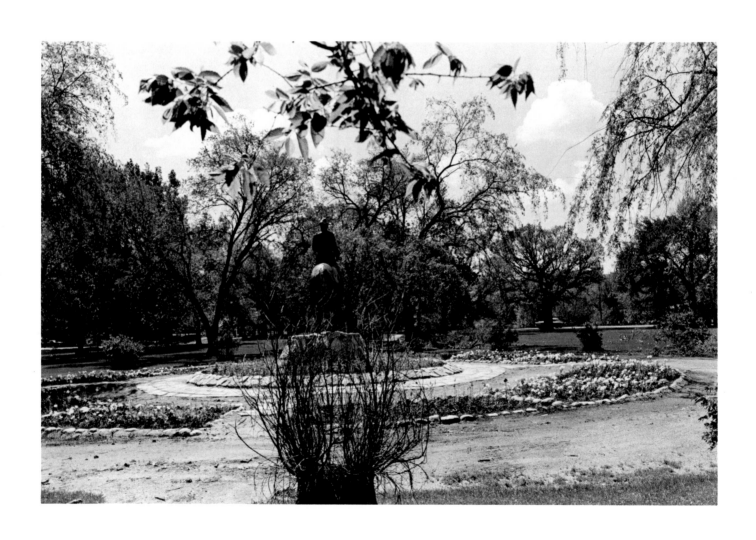

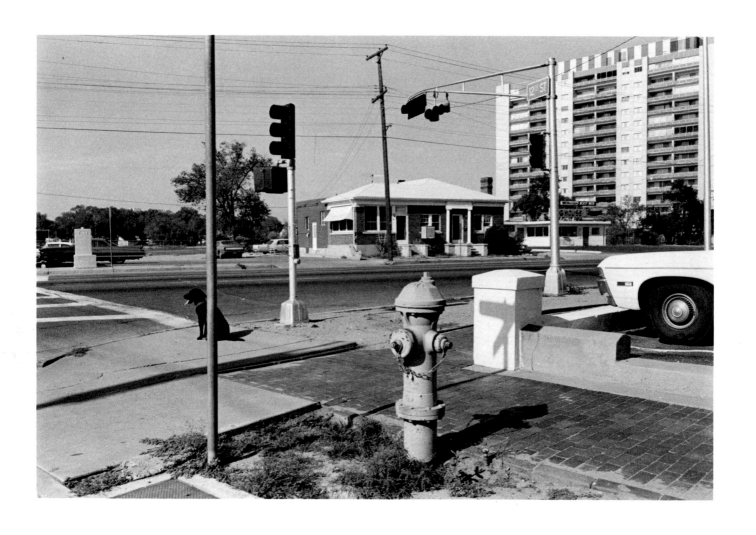

Dear Jonathan

Here are the Polaroids from the „ALBUM„
First page in Album towards End of Album

```
┌─────────────────┐    ┌──────────────────────────┐
│ ┌───────────┐   │    │ ┌──────┐     ┌──────┐    │
│ │    1      │   │    │ │  4   │     │  7   │    │
│ └───────────┘   │    │ └──────┘     └──────┘    │
│                 │    │                          │
│ ┌───────────┐   │    │ ┌──────┐     ┌──────┐    │
│ │    2      │   │    │ │  5   │     │  8   │    │
│ └───────────┘   │    │ └──────┘     └──────┘    │
│                 │    │                          │
│ ┌───────────┐   │    │ ┌──────┐     ┌──────┐    │
│ │    3      │   │    │ │  6   │     │  9.  │    │
│ └───────────┘   │    │ └──────┘     └──────┘    │
└─────────────────┘    └──────────────────────────┘
```

This is my selection. and I realize that even
the selecting of these 3 pages takes away
from the Anymosi Anonymous-ness
quality which the Album had.
Now they become more like my „PHOTOGRAPHS„
I thought I'd send you SNAP-SHOTS —
gone is that Time of S.S. But I hope
that they are POLAROIDS.
 Whatever
 Salut
 Robert

ROBERT FRANK

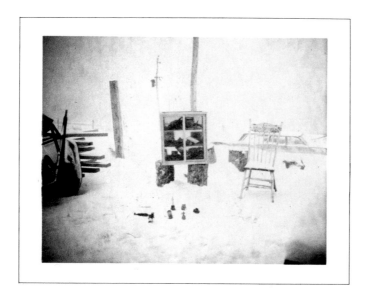

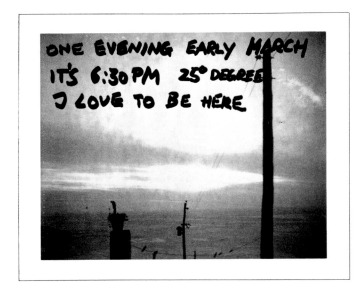

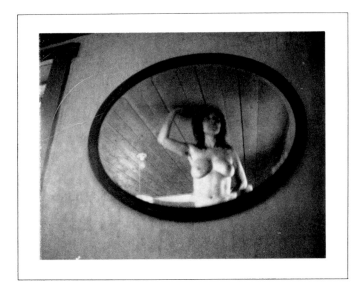

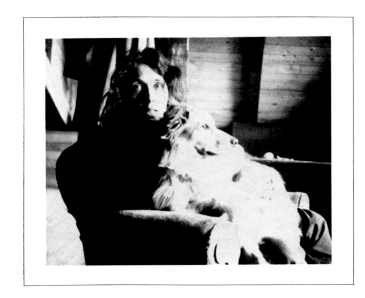

CONTRIBUTORS

RICHARD ALBERTINE
is a professional photographer, house builder, and venturer who currently lives in the mountaintop ghost town of Silver City, Idaho, where he is restoring one of the original buildings for his home. He is also documenting the area for a photographic book.

WALKER EVANS
has had an abiding interest in picture postcards, newpaper and newsreel photographs, and snapshots since he first started photographing in the late twenties. The postcards reproduced with his article were originally in color and are from his own collection.

ROBERT FRANK
now lives in an isolated part of Nova Scotia. He occasionally uses a Polaroid camera to photograph his house, the scenery, and his friends.

LEE FRIEDLANDER
Lee Friedlander is constantly involved in making photographs similar to the ones reproduced here. His photographs are a part of the permanent collection at the Museum of Modern Art and a book of his photographs, *Self Portrait*, was published in 1970.

EMMET GOWIN
teaches photography at Princeton University and holds a 1974 Guggenheim fellowship in photography. He has studied with Harry Callahan and Frederick Sommer and considers both as important influences on his work.

STEVEN HALPERN
is a photographer and professional cook who lives in Cambridge, Massachusetts. He received a master's degree in medieval social history from the University of Toronto. He is currently collaborating on a biography of Forence Luscomb, the suffragist and political activist.

GUS KAYAFAS
teaches photography at the Massachusetts College of Art. He has studied with Harry Callahan, Aaron Siskind, and Minor White. Many of his photographs in this book were taken with infrared film.

JOHN A. KOUWENHOVEN
is professor of English at Barnard College in New York City. He is the author of the well-known books *Columbia Historical Portrait of New York* and *Made in America*.

JOEL MEYEROWITZ
discovered photography by chance in 1962, when he saw some photographs by Robert Frank. A book based on photographs he made as a Guggenheim fellow is about to be published. He is currently working and printing in color.

WENDY SNYDER MACNEIL

teaches photography at Wellesley College. Her biographical project of bringing together family album photographs and her own portraits was supported by a Guggenheim fellowship in 1973. In 1970 the MIT Press published a book of her photographs of Boston's open-air market: *Haymarket*.

LISETTE MODEL

has had a great influence on contemporary photography both as a photographer and teacher. She came to photography quite by accident after an early background in music. Currently teaching at New York's New School of Social Research, she also lectures widely. She spent the summer of 1974 printing and photographing in San Francisco.

TOD PAPAGEORGE

has recently joined the photography faculty at MIT. The work presented here was made with a Leica on a Guggenheim fellowship during 1970 and 1971. He is currently photographing with a large format, rangefinder camera. His essay is his first published writing on photography.

NANCY REXROTH

has been living and photographing in Albany, Ohio, for the last few years. Her work in southeastern Ohio with the Diana camera has been supported by a grant from the National Endowment for the Arts.

PAUL STRAND

has just finished work on his latest book, *Ghana, An African Portrait*. At his home in France he has been photographing his garden with a small camera mounted on a tripod. He calls the series he is making "On the Other Side of My Doorstep."

JUDITH WECHSLER

teaches art history at MIT. She has just completed a book on Cézanne and is currently doing research in the United States, in England, and in France on Daumier's concept of character and caricature.

HENRY WESSEL, JR.

teaches photography at the San Francisco Art Institute. He was a Guggenheim fellow in 1971 and has had a one-man show at the Museum of Modern Art.

GARRY WINOGRAND

has taught for the past two years at the University of Texas at Austin. Since 1969 he has been producing a photographic record of the impact of the news media on public events. He is currently finishing a photographic book tentatively entitled *Aren't Women Beautiful*.

BILL ZULPO-DANE

painted and sculptured until 1970, when he began to photograph. Since then he has distributed his work by photo-mailings. He held a Guggenheim fellowship in 1973. He teaches high school in Berkeley, California.

ACKNOWLEDGMENTS

For help in the preparation of this book, the editor is indebted to Wendy Snyder MacNeil, Tod Papageorge, and particularly to Minor White, who first suggested this project and supported every aspect of it from start to finish. He also expresses his thanks to Robert Frank, Lisette Model, Paul Strand, and John Szarkowski for their lively and invaluable comments on the nature of the snapshot.

The portfolios of photographs are reproduced through the courtesy of the photographers themselves except in the following instances. Garry Winogrand's prints and Emmet Gowin's prints on pages 9, 12(top), 13 and 15 were provided by Light Gallery, New York City. Bill Zulpo-Dane's prints on pages 96, 97, 101, 102, and 104 were provided through the courtesy of The Museum of Modern Art, New York City.

The photographs on the cover (1929) and the title page (1937, Albert Salomon and son, Frank) and the illustration snapshots on pages 3, 24, 67 (right), 106, 107 (photograph by Sammy Gerstein of his wife, Betty, 1944), and 108 were provided by Wendy Snyder MacNeil. The photographs of Andre Kertesz on page 25 and Walker Evans on page 27 are reproduced by special permission of the photographers. The Edward Weston photograph on page 25 is courtesy of the Estate of Edward Weston. Henri Cartier-Bresson's photographs on page 26 are reproduced courtesy of Magnum. Eugene Atget's photograph on page 27 is courtesy of The Museum of Modern Art, New York City. The photographs of Paul Strand on page 48 are reproduced by special permission of the photographer. The Hawes' daguerreotype on page 64, *Mrs. J. J. Hawes* and *Alice* (a gift of Edward Southworth Hawes in memory of his father Josiah Johnson Hawes), and the painted miniature on page 65, Sarah Goodridge's *Self Portrait* (a gift of Miss Harriet Sarah Walker), are reproduced courtesy of the Museum of Fine Arts, Boston. The Lartigue photograph on page 67 is courtesy of the Jacques Henri Lartigue Limited Edition Portfolio published by Witkin-Berley Ltd., New York City. The postcards on pages 94–95 are reproduced from *Fortune*, May 1948, through special permission of Walker Evans and *Fortune Magazine*, © 1948 Time Inc. The photographs of Lyndon Johnson, Amedeo Modigliani, and Franz Kafka on pages 109–111 are courtesy of Links Books, New York City.

The article by Walker Evans on pages 94–95 has been specially adapted by the editor and Mr. Evans from two articles by Mr. Evans first published in *Fortune Magazine* in May, 1948 and January, 1962. These articles are © 1948 and © 1962 by Time Inc. They are printed here by special permission of *Fortune* and Walker Evans.

The article by John A. Kouwenhoven on pages 106–108 is made up from excerpts from Mr. Kouwenhoven's lecture "Living in a Snapshot World." It is printed here with the kind permission of the author.